50+
1329
D1325046
770

# CONTENTS

# THE INVENTION OF
# PHOTOGRAPHY
## THE FIRST FIFTY YEARS

Quentin Bajac

CRAVEN COLLEGE

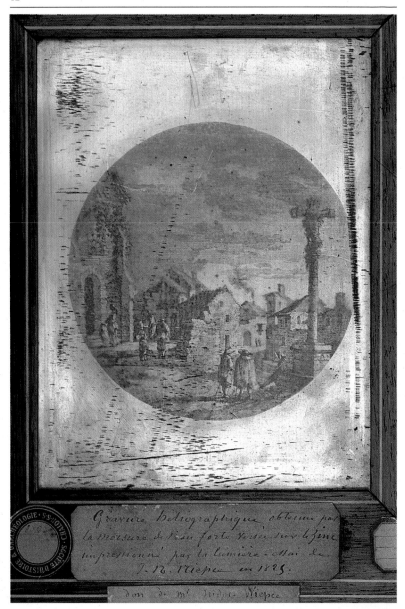

Gravure héliographique obtenue par
la morsure de l'eau forte sur l'étain
impressionné par la lumière - Mai de
J. N. Niepce en 1825.

don de m. Isidore Niepce

During a meeting of the French Academy of Sciences held in Paris on 7 January 1839, the astronomer and physicist Louis-François Arago, an eminent figure in scientific circles of the time and a Republican deputy, presented a new process that allowed images created in the camera obscura, the drawing apparatus employed by artists since the 16th century, to be reproduced mechanically without any manual intervention.

CHAPTER 1

# 1839, THE BIRTH OF PHOTOGRAPHY?

The birth of photography was a slow process. Over twenty years separated the first attempts made by Niépce (heliographic plate of 1825; opposite) from the invention of the daguerreotype (right; Daguerre's first camera obscura, with his signature and the mark of its manufacturer, Giroux).

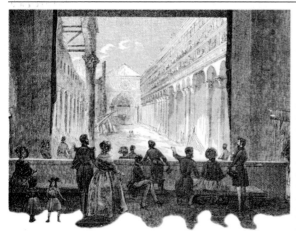

According to Arago, despite their lack of colour, the images created in this manner, views of Paris or still-lifes, stood out for the incredible sharpness in detail, which any draughtsman would have found it impossible to equal. Listing the various possible applications within the realms of science and the arts, Arago urged the French State to acquire it as soon as possible from its inventor Louis Jacques Mandé Daguerre, who had christened it the 'daguerreotype'.

## An astonishing invention

The surprise was genuine. Apart from brief mentions in the Parisian press since 1835, it had remained a well-kept secret. Rumours concerning the invention had been circulating in scientific and artistic circles in the city for several years. Until then, however, only very few of those close to Daguerre and certain members of the Academy of Sciences had had the privilege of seeing the images. The announcement was received with added enthusiasm by the press since the inventor was no stranger to the general public. Daguerre, who for over fifteen years had been director of the Diorama

Situated close to the Place de la République, Daguerre and Bouton's Diorama had been an attraction for Parisians and visitors to the city since 1822 (left). By means of a complex mechanism and a clever play of light and mirrors, a canvas measuring 22 × 14 metres (72 × 46 feet) stretched in front of the spectators was gradually animated, passing from light to dark. The illusion was complete, the *trompe-l'œil* perfect, the astonishment unanimous. Each performance lasted about quarter of an hour and encompassed most of the great Romantic themes: mountains, Gothic ruins, Italian landscapes. It enjoyed immediate success and, in 1823, a subsidiary was opened in London. One of its first visitors was Constable who found it 'very pleasing', but did not consider the show to belong to the realms of art as its aim was deception.

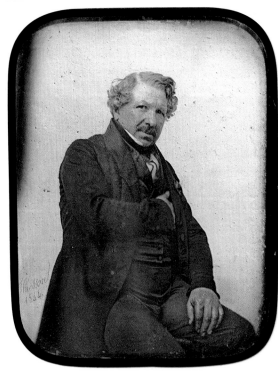

Light was the great passion for Daguerre (left). Through his clever use of it, the man who started out in charge of stage design at the Ambigu Comique and then the Opéra revolutionized the science of stage effects completely. His love of illusionism and *trompe-l'œil* subsequently led him to create the Diorama (opposite above): a cross between optics, painting and chemistry, the enterprise already called for the knowledge he later put to use in developing the daguerreotype. A newspaper of the time commented: 'To the illusion produced by the ability of the painter is added the prestige of the astonishing compounds created by the chemist.'

At the beginning of his career, Daguerre was familiar with the camera obscura (opposite below). The images it produced fascinated him, yet he also found them dissatisfying. From the early 1820s, Daguerre dreamt of being able to fix them directly, without passing through the drawing phase. In 1832 he wrote: 'Since my last show with the Diorama, I have done nothing but concentrate on MY GREAT WORK, on the effects that can be obtained with light.'

– a show much loved by the Parisians, based on subtle plays of light – was a public figure associated with images.

In the absence of any information regarding the method of production employed, the incredible belief emerged that through this process nature could reproduce itself, in the most minute detail, without the intervention of the human hand. Daguerre was not the first to have dreamed of this. Others had tried before him, but without success. The considerable advances made in the previous century in the fields of chemistry and physics as well as optics, however, finally enabled the dream to become reality in the first half of the 19th century.

From a purely technical point of view, photography seemed to be the fruit of a long process that had

originated in the 18th century with research into the sensitivity of light to silver salts (silver nitrate or silver chloride) by the Germans Johann Heinrich Schultze (1687–1744) and Carl Wilhelm Scheele (1742–86), by Jean Senebier (1742–1809) in Geneva or by the Englishman William Lewis. Following on from Lewis, at the beginning of the 19th century, Thomas Wedgwood, son of the celebrated porcelain manufacturer, succeeded in obtaining the impressions of objects and plants placed directly on a sheet of sensitized paper, without fixing them for any length of time. These experiments were widely spread in European scientific circles. Thus the basic rules governing the creation of the photographic image were known well before 1839. In 1803, the Englishman Thomas Young (1773–1829) and, on the other side of the Atlantic, Samuel Morse, the future inventor of the telegraph, had produced faint and fleeting negative images in 1822. Another American, the astronomer John Draper (1811–82), and the Englishman James B. Reade (1801–70) had also carried out experiments in the same field in the early 1830s.

### Niépce and Daguerre

The problem of how to fix images was resolved in the mid-1820s by Nicéphore Niépce (1765–1833). Born to an eminent family in Chalon-sur-Saône and initially destined for a career in the Church, Niépce began his research in this field late, at the age of fifty-one, in 1816, finally satisfying a desire harboured for twenty years. After having tried briefly – following the example of Wedgwood – to obtain simple negative impressions of objects laid out on a sheet of sensitized paper, he embarked upon experiments to create images with the aid of the camera obscura. His experiments were slow and laborious, consisting of periods of stagnation, steps backwards and sudden leaps forward. Having tested various substances sensitive to light, Niépce opted in the early 1820s for asphalt or bitumen of Judea, a viscous liquid, consisting of carbon dust dissolved in essential lavender oil which provides a

Images created by Niépce (below), which he referred to as 'viewpoints' or 'heliographs', are extremely rare. The most famous is unquestionably *View from a Window at St-Loup-de-Varennes* (opposite), the first heliograph to survive until the present time

and the one reproduced in most histories of photography. It was created in 1826 or 1827, with, it would seem, an exposure time of several days. The original pewter plate is nowadays more difficult to decipher than the heavily retouched reproduction in general circulation (opposite). It shows the outlines of buildings on Niépce's estate and a pear tree, to the right of the tower on the left.

brilliant and uniform varnish. Around 1824, he obtained his first images on metal and stone, from the window of his estate at St-Loup-de-Varennes. He christened this process 'heliography', 'sun drawing'.

Around the same time, rumour of this research, close as it was to his own interests, began to reach Daguerre. For many years he had dreamt of being able to fix the images obtained in the camera obscura he used in the creation of his Dioramas. The association between the two men, sealed in 1827, came to an end following Niépce's death in 1833.

Daguerre subsequently pursued his work alone, assisted from 1836 by Eugène Hubert, a young architect. In contrast to Niépce, Daguerre very soon began working towards clarity rather than multiplicity of the image. In 1837, he finally perfected his process: it consisted of a copper plate sensitized with bitumen of Judea, exposed in the camera obscura, then developed by vapour of mercury, producing an image characterized by very great detail.

This example of an early work in the history of photography has experienced many tribulations: sent by Niépce in 1827 to Dr Bauer, a member of the Royal Society in London, the image was subsequently sold twice at auction later in the century. Exhibited in London in 1898, it then disappeared for over fifty years, laying forgotten in a trunk that had been placed in storage. It only resurfaced thanks to the efforts of the photographic historian and collector Helmut Gernsheim. In 1964, he donated the image to the University of Texas.

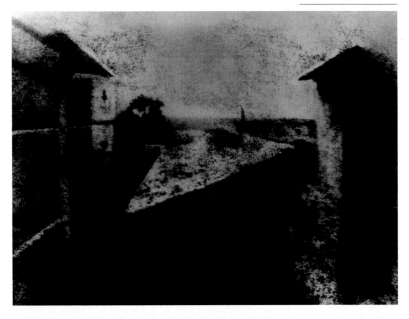

After the failure of his attempts to market the process, Daguerre sought backing in official circles: in the autumn of 1838 he approached François Arago, who was extremely enthusiastic.

## Disputes over precedence

Arago's announcement at the very beginning of 1839 resulted in an incredible escalation of events. The deliberate lack of information surrounding the method of producing the images gave rise to all kinds of speculation. Some were doubtful, talking of magic, while others came forward and claimed precedence as far as the discovery of a photographic process was concerned, showing to what extent Daguerre's invention was in the air at the time.

The most significant of these claims came from England where, on 31 January 1839, William Henry Fox Talbot (1800–77) presented a paper to the Royal Society in London describing his own photographic process. A scientist and man of letters, well-versed in natural history, archaeology and numismatics as well as the fine arts, Fox Talbot had been carrying out experiments with light since 1834. In 1835, he succeeded in creating his first 'photogenic drawings', negative impressions of objects or plants arranged on a sheet of paper sensitized with silver salts. Shortly afterwards, he obtained the first images, again negative, produced with the aid of small camera obscuras. Fox Talbot does not appear, however, to have grasped the significance of his experiments immediately, interrupting or slowing them down over the next few years and not taking them up again until the end of 1838.

Upon hearing of the discovery that had taken place in Paris, Fox Talbot began his research again, endeavouring

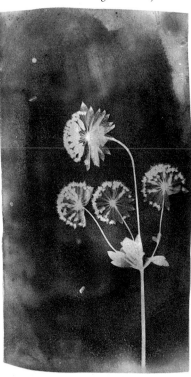

While presenting his process to the Royal Society, Fox Talbot declared that flowers and leaves were among the first objects he tried to reproduce. A man of science, passionate about botany, he had been creating impressions of plants since 1834: placed against a sheet of sensitized paper and exposed to the light, they produced a negative image of their outline (above).

to publicize it as widely as possible, particularly in the press. Forced to show that he was acting in good faith, he sent some of his photogenic images in February to the Academy of Sciences in Paris, in addition to details of his method, which indeed proved to be truly original. While, in a similar way to Daguerre, Fox Talbot had employed silver salts as sensitizers, directly obtaining in the same manner a single image (without recourse to a negative), the support he used – paper – as well as the actual process he adopted were entirely different. The resulting images were, of course, still far from possessing the precision of Daguerre's plates; nevertheless, from this moment on, Fox Talbot saw himself as Daguerre's most serious rival.

Blurred images emerging faintly from the shadows: such was the appearance of

The most astonishing claim, which passed almost unnoticed at the time, was that of Hercules Florence. A native of Nice, an artist and adventurer, this painter emigrated to Brazil around 1820 and remained unknown by historians of photography until the 1970s. According to the annotations that survive in the notebook recording his experiments, by 1833, in a remote village in the interior, he had succeeded in capturing images

*Latticed Window (with the Camera Obscura)*
*August 1835*

*When first made, the squares of glass about 200 in number could be counted, with help of a lens.*

the earliest surviving images created by Fox Talbot (top), as in the example of *View from a Window at Lacock Abbey*, taken in the summer of 1835 (above). In order to capture and retain the light, Fox Talbot set up miniature camera obscuras, referred to as 'mousetraps' by his wife.

created in a camera obscura and in sketching the outline of a negative-positive process. In October 1839, he presented his discoveries in a journal published in São Paulo.

## Photographic processes of all descriptions

The announcement of Daguerre's invention and, above all, the publication of a certain number of production secrets from Fox Talbot's process soon led to the appearance of numerous novice photographers: some of them succeeded, occasionally in record time, in perfecting their own processes. Sometimes, unfortunately, no images survive, making the truth of their claims difficult to verify, as in the case of Maksymilian Strasz, a Pole, or the Frenchmen Desmaret, Lassaigne and Vérignon, who, in 1839, deposited their photographic processes in a sealed envelope before the French Academy of Sciences.

In other instances, rare images have fortunately survived: as in the case of Carl August von Steinheil (1801–70) and Franz von Kobell (1803–82), members of the Academy of Sciences in Munich, who, early in 1839, elaborated their process, which they subsequently demonstrated in the summer of the same year, before the queen of Bavaria at the palace of Nymphenburg. Other examples include that of the astronomer Jacob Carl Enslen, again in Munich; or, in Edinburgh, Andrew Fyfe and Mungo Ponton, respectively a student and a banker, who revealed the results of their experiments under the auspices of the Royal Society for the Arts. The list is far from being exhaustive.… In June 1839, *Athenaeum*, a journal published in London, claimed that not a day went by without receiving a letter reporting a discovery or an imagined improvement in the art of photogenic drawing.

Of all the inventors to emerge in 1839, two in particular are worthy of special attention: John Herschel (1792–1871) and Hippolyte Bayard (1801–87). Both share the merit of having developed, within an extremely brief period of time, at the beginning of the year in question, an original and highly reliable photographic process directly on to paper. The former,

The developments made by Carl August von Steinheil in Munich in 1839 are typical of the path followed by the pioneers of photography from 1839 to 1840. Predisposed towards the new technique because of his training as an astronomer and physicist, he created, in March 1839, with the help of Franz von Kobell, professor of mineralogy at the city's university, an original process on paper (opposite) similar in many respects to that used by Fox Talbot. At the end of 1839, however, he abandoned it and invented, notably, the first miniature camera based on Daguerre's process. Motionless subject matter, views of architecture and reproductions of works of art were the motifs favoured by the earliest aspiring photographers: on the plate illustrated (opposite), made in spring 1839, the earliest views of Munich (the sculpture museum, towers of the cathedral) are placed alongside copies of works by local artists, such as von Foltz or Gail.

an English astronomer and physicist, worked closely with Fox Talbot. On 14 March 1839, he presented his own method, based on experiments initiated barely six months earlier, before the Royal Society. In addition to

This experimental plate is now known only through black-and-white reproductions made in the 1930s.

his process, however, it was the influence that he exerted on Fox Talbot's work that has earned him a prominent position in the history of photography. In 1831, while working together on experiments, he had drawn his friend's attention to the sensitivity to light of platinum salts. In 1839, he was the first to employ a new product, sodium

Despite their quality, Bayard's images, such as those in his notebook of 1839 (left), could not compete with the accuracy of Daguerre's images, particularly his still-lifes (above). Most of the commentators at the time were amazed at the precision of Daguerre's work, which captured a number of details invisible to the naked eye. Arago defined them as 'screens on which all that the image contains is reproduced in the minutest detail with incomparable sharpness and accuracy'. Herschel, who visited Paris in May 1839, was struck by their precision and wrote enthusiastically to Fox Talbot with the words: 'It is hardly saying too much to call them miraculous. Certainly they surpass anything I could have conceived as within the bounds of reasonable expectation.'

thiosulphate, to fix the images obtained indefinitely. This technique was later adopted by Fox Talbot and, shortly afterwards, by Daguerre for his own daguerreotypes.

The Frenchman Hippolyte Bayard came from a very different background. A civil servant in the Ministry of Finance in Paris, he frequented the artistic circles of the capital and, it would seem, a few days after Arago's announcement, began experiments of his own. He made

rapid progress, being in a position by 5 February 1839 to show his first attempts to César Desprets, a member of the Academy of Sciences. On 20 March, two months after he had started, he produced his first direct positive images, not only the impressions of objects but also still-lifes of sculptures and casts. His process soon allowed him to capture the human figure, an astonishing achievement for someone who was self-taught, with no prior knowledge of chemistry or optics.

Photography or photographs? Niépce's heliographs, Daguerre's daguerreotypes, Fox Talbot's photogenic drawings: the variety of vocabulary gives some idea of how confused the situation was. During the same period, the term 'photograph' was coined in the four corners of Europe by scholars independently of each other – the English physicists Wheatstone and Herschel, the German astronomer von Mädler. It seems, however, that Hercules Florence had been using it since 1833. It did not really pass into common usage until the late 1850s, when it supplanted all other terminology permanently.

## A gift to humanity

For the time being, the daguerreotype outshone all other experiments. Hit by the destruction of his Diorama in a fire at the beginning of May and uneasy about the work of his two main rivals – Fox Talbot and Bayard – Daguerre put pressure on Arago to press his cause. On 14 June, he was received by the minister of the Interior, with whom he struck an agreement: the State would acquire his photographic processes and the manufacturing secrets of the Diorama, in return for an annual pension for life

In contrast to the cinema, the daguerreotype enjoyed official recognition right from the start, thanks to Arago. Scientific interest as much as political

motivation lay at the root of the backing that this scholar and Republican deputy gave to Daguerre: the special law which he made the chambers pass (above) appeared to be in keeping with his Republican and Saint-Simonian convictions on the pivotal role the State should play in the dissemination of knowledge.

of 6000 francs for Daguerre and 4000 francs for a descendant of Nicéphore Niépce. Arago has often been criticized for having dismissed the processes invented by Fox Talbot and Bayard in such a hurried way, but it must be recognized that in 1839 Daguerre's process was infinitely more successful as far as the definition of the image was concerned than those of his principal rivals. Scientific circles in Paris remained unconvinced by the images transmitted by Fox Talbot: the physicist von Humboldt referred to them as 'whitish marks', 'old prints over which someone has rubbed his elbows'.

Presented to the king of Bavaria by Daguerre in 1839, the two views of the Boulevard du Temple illustrated below, one on either side of a still-life, were taken from one of the windows of his house, behind the Diorama, probably in spring 1838. Perhaps Samuel Morse saw these images at Daguerre's

On 19 August 1839, at a joint formal meeting of the Academy of Sciences and the Academy of Fine Arts, Arago finally revealed the secret of how Daguerre's images were produced. In a Promethean gesture, the process, barely acquired from its inventor, was offered by the French State to all humanity: now free from any rights, it was able to become established without restriction in France and abroad, the notable exception being England, where Daguerre's invention remained protected by a patent taken out by its inventor.

A few days after this memorable meeting, one observer commented that 'the opticians' shops were full of amateurs yearning for a daguerreotype; everywhere they were to be seen focusing on monuments. Everyone

house in March 1839. He pointed out a man having his boots polished: 'His feet were compelled, of course, to be stationary for some time, one being on the box of the boot black, and the other on the ground. Consequently his boots and legs were well defined, but he is without body or head, because these were in motion.'

wanted to copy the view from his own window.... The poorest attempt...gave rise to indescribable joy, so new was the process then, and it appeared truly wonderful'. A certain number of demonstration sessions were offered at the Palais d'Orsay throughout September. On these occasions, several views of the Seine and its embankments were taken by Daguerre himself, the exposure time being roughly fifteen minutes according to observers. At the same time,

On 19 August 1839, Arago presented Daguerre's process to a joint meeting of the Academy of Sciences and Academy of Fine Arts (above): only a few days later, optical and chemical equipment (below) and instruction manuals were

# HISTORIQUE ET DESCRIPTION
## DES PROCÉDÉS DU
# DAGUERRÉOTYPE
## et du Diorama,

### PAR DAGUERRE,

demonstrations with a fee for admission were organized in the provinces by various practitioners who, more often than not, presented themselves as pupils of Daguerre. Complete kits were available from certain Parisian opticians, notably Chevalier and Lerebours or Daguerre, in return for the princely sum of around 300 francs, the equivalent of one hundred days' work for a labourer.

Daguerre's process rapidly spread across borders: views of Paris and some still-lifes were sent to the rulers of Austria, Bavaria, Russia, Prussia and Belgium, who hastened to display them. On 11 September, its first public demonstration in London was organized by Monsieur de Sainte-Croix, a mysterious Frenchman. People everywhere were filled with wonder. The

available in Paris, where the number of amateur daguerreotypists rapidly grew. Some indication of the craze is given by the numerous reprints of Daguerre's *Historique et description des procédés du daguerréotype et du Diorama*, which was translated into several languages from 1839.

invention then spread like wildfire, going beyond the borders of Europe: the painters Horace Vernet and Frédéric Goupil-Fesquet set sail from Marseilles with their apparatus, bound for Egypt, where, from November onwards, they 'daguerreotyped like lions' and presented the new medium to the pasha. It was, however, in the United States, where Daguerre was particularly anxious to establish his process, that the invention enjoyed the most rapid and lasting success. At the end of October 1839, a window on Broadway displayed the first daguerreotype created by an American amateur, a certain D. W. Seager. Samuel Morse, the astronomer John William Draper and, in Philadelphia, Robert Cornelius all tried out the new medium. In December, François Gouraud, sent to New York by Daguerre to market his equipment, organized there the first public exhibition of Daguerrean plates, sent from France. At the end of the month, the invention reached South America, thanks to Father Louis Compte who had disembarked in Salvador de Bahia equipped with one of Daguerre's cameras.

## Unhappy rivals

The shattering and carefully orchestrated success of the daguerreotype threw all other processes into the background. For Fox Talbot, 1839 proved to be a particularly frustrating year: bad weather meant his experiments were restricted and unfruitful. No official support was forthcoming. It was not until the following autumn that he made the decisive step forward, finally completing a new negative-positive process: starting with a negative image, created in the camera obscura and then developed, it was by now perfectly possible for him to obtain several positive prints, thus propelling

In October 1840, frustrated by the lack of recognition, Bayard chose to portray himself as a 'drowned man', pushed by indifference towards suicide. 'The mortal remains you are now looking at are those of M. Bayard.... The Academy, the King and all who have seen these drawings, which he considered imperfect, admired them.... All this does him great credit and has not earned him a farthing. The government, which supports M. Daguerre far more than necessary, declared itself unable to do anything for M. Bayard, and the unhappy man therefore drowned himself in despair.'

photography into the era of the multiple image. Moreover, the method for obtaining the negative, by revealing a latent image, allowed him to dissociate the viewpoint of later operations and to reduce the exposure time considerably: a few days later, in October 1840, he finally produced the first portraits of his wife Constance. At the beginning of 1841, disheartened by the disappointments of 1839 and still without any support from the British Establishment, he decided to protect his invention, which he christened calotype (from the Greek *kalos*, 'beautiful'), by taking out several patents.

As for Bayard, although the images he exhibited in Paris in June 1839 received the notice of the press, any official recognition was late in arriving, despite the support of the Academy of Fine Arts which stressed the quality of his work. It was not until two years later that the Société libre des beaux-arts awarded him a medal. Meagre results in comparison to the triumph of Daguerre: his disappointment is blatant in *Self-portrait as a Drowned Man*, which he produced in October 1840. At the beginning of the 1840s, the daguerreotype seemed truly invincible.

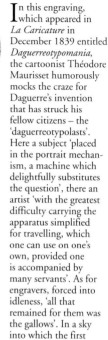

In this engraving, which appeared in *La Caricature* in December 1839 entitled *Daguerreotypomania*, the cartoonist Théodore Maurisset humorously mocks the craze for Daguerre's invention that has struck his fellow citizens – the 'daguerreotypolasts'. Here a subject 'placed in the portrait mechanism, a machine which delightfully substitutes the question', there an artist 'with the greatest difficulty carrying the apparatus simplified for travelling, which one can use on one's own, provided one is accompanied by many servants'. As for engravers, forced into idleness, 'all that remained for them was the gallows'. In a sky into which the first aerial photographers soar, the smiling sun bears the features of Arago.

Various statements, particularly from those close to Daguerre, have long been thought to show that he never practised portraiture, the length of exposure time rendering any attempts not only impossible but also inconceivable. It is generally acknowledged that credit for the first serious efforts should go to several American daguerreotypists in the autumn and winter of 1839–40: Robert Cornelius, Alexander Wolcott and John Johnson, or Henry Fitz (left).

Contemporary accounts tell of numerous attempts, some more successful than others, carried out on this side of the Atlantic, from September 1839: in Belgium, by Jobard and a certain Auguste Florenville who supposedly executed 'the portrait of a young girl in a garden' in September. In October in France, Dr Donné produced a portrait with the face powdered to absorb the light and reduce the exposure time. More importantly, in his correspondence Daguerre mentions some 'quite successful' attempts at portraiture carried out between 1835 and 1837, including the recently discovered plate, from around 1837 (opposite).

The 'permanent mirror which retains all impressions' was immediately greeted with enormous enthusiasm by the public, although the cost of the apparatus meant that its use was restricted. Praised for its accuracy and detail, the daguerreotype conquered the collective imagination. The term 'daguerreotype' was hugely successful: for over twenty years, in the writings of art critics and journalists, it meant absolute truth to the subject.

## CHAPTER 2
## COPPER, PAPER, GLASS, 1840–55

Despite a notable reduction in exposure times, visible in this scene of a fire at Oswego (1853; right), the daguerreotype only enjoyed a decade of success, before gradually being supplanted by the process of collodion on glass that brought together great detail and the ability to produce numerous prints (left).

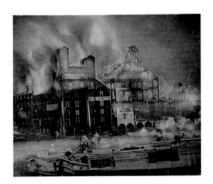

Small in dimension, rarely measuring more than 16 × 21 cm (6¼ × 8¼ in.) – the so-called 'full plate' sold commercially – the daguerreotype, however, also had its faults: excessively shiny surface, lengthy exposure times, unique images that could not be mass produced and lack of colour. In 1840, a major improvement was made to the process: Hippolyte Fizeau, a physicist and member of the Academy of Sciences in Paris, succeeded in gold-toning the image, a method that reduced the 'mirror effect' of the plates. The greatest problem, however, remained the exposure time, which was still too long to capture the human figure adequately. The issue was complex, with numerous factors coming into play: the weather, the atmosphere, the time of day, the time of year, the nature of the lens and of the subject to be photographed, the quality of the preparation of the plates as well as their size. Exposure times also varied considerably according to the ability and experience of the photographer, rendering any generalization problematic. Nevertheless, over the next few years, they were greatly reduced: to obtain a successful image, at midday in high summer, according to Daguerre it took 10 to 120 minutes in 1838, 8 to 12 in 1839 and, according to the American Seager, 5 during the winter of 1839–40. Experiments on both sides of the Atlantic on new 'accelerating substances' meant the necessary time had fallen to below 10 seconds by 1840.

In addition to the complex apparatus (below), another disadvantage of the daguerreotype was the support of the image itself: the heavy copper plate (above) became scratched or oxidized.

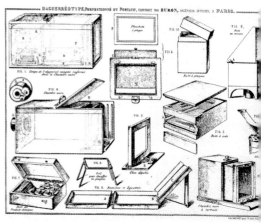

## Daguerreotype portraiture

These successes paved the way for the commercial exploitation of the process in the field of portraiture. In 1840, the first commercial studios opened in the United States on the East Coast: in New York in spring 1840, Wolcott and Johnson were able to operate within approximately ten seconds thanks to a device of their own invention. The great European capitals, London and Paris in particular, followed suit. After working in the coal business, the industrialist Richard Beard (1802–88) obtained a licence from Daguerre to adopt the daguerreotype in England and modified Wolcott and Johnson's method: in March 1841 he opened in London what is sometimes considered to be the first portrait studio in Europe. In June of the same year, François Arago presented before the Academy of Sciences some portraits produced by the Bisson brothers in 10 to 12 seconds.

A seasonal activity, photography was still highly dependent on light: journalists and contemporaries have described, often in mocking tones, these early studios, perched

Protected in caskets of leather or moulded plastic, as in the United States (below), framed under glass in order to be displayed vertically, as in France or Germany, or even set, in the manner of a precious stone, to adorn a piece of jewelry…the daguerreotype soon rivalled the miniature portrait among the middle classes. Below: patent for Wolcott and Johnson's method.

No 1582

A. S. Wolcott, Concave Reflector + Plate for taking likenesses. May 8th, Patented 1840.

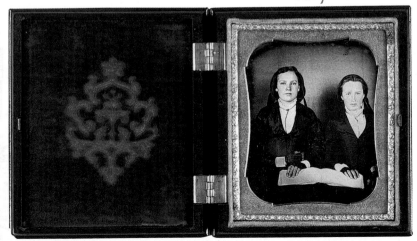

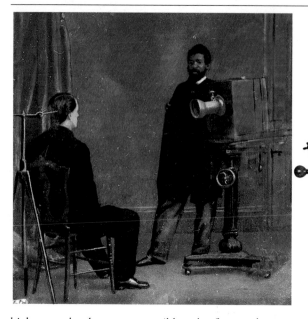

high up under the eaves, accessible only after a trek up
the stairs, in order to have their throat overcome upon
arrival by the acrid smell of chemical substances. The
sitter then entered a veritable 'glass cage', sparsely
furnished, the window panes often blue-tinted to
reduce the exposure times to the sun and render the
sitting less uncomfortable. At the centre of the room
were two pieces of equipment: the photographic
apparatus and the instrument intended to hold the pose,
a chair or armchair fitted with a headrest enabling the
model to remain still. Humorists compared it to the
pillory, a pair of pliers, the 'widow of Nuremberg' and
other instruments of torture and the sitting itself, which
involved remaining perfectly still in full sunlight as the
seconds ticked by, to a scene of torture, invariably
resulting in haggard faces with frozen features. Looking
at the static and tense appearance of most of these
portraits, the accusation contains an element of truth:
'The constraint imposed on the face under the still
too lengthy influence of sunlight makes these portraits

resemble real victims of torture,' Valicourt wrote in his treatise on the daguerreotype in 1845. 'We work in the shade' rapidly became a sought-after selling point.

Despite these drawbacks, the daguerreotype portrait enjoyed considerable success throughout the 1840s. While in 1841 the number of Parisian studios concentrated in the area around the Louvre (Palais-Royal and Pont-Neuf) hardly amounted to more than a dozen, ten years later it had risen to around fifty, without counting various non-specialist businesses practising, among other activities, the daguerreotype.

In the provinces, the spread was slightly less rapid but, in 1842, studios opened in Strasbourg (Finck), Marseilles (Desmonts) and Lyons (Dolard). To these must also be added the extremely high number of itinerant daguerreotypists.

In England and Wales, where Richard Beard had held a monopoly on the use of the process since 1841, the process did not flourish in quite the same way. While selling licences to a number of operators in the provinces for the staggering sum of around 1200 pounds, Beard also did his utmost to pursue relentlessly any offenders by instituting numerous proceedings against them. It is therefore understandable that in London in 1850 there were barely six or seven establishments.

Production in the largest studios exceeded a thousand plates a year, whereas a miniaturist produced three times less. In London, the

– Tiens, ma femme, v'là mon portrait au Daguerréotype que je te rapporte de Paris. – Pourquoi donc est-ce que tu n'as pas aussi fait faire le mien pendant que tu y étais? égoïste va!...

• Upon entering, you will experience a feeling of revulsion similar to that provoked by a dentist's surgery,• wrote a newspaper of the time with regard to the daguerreotypist's studio (opposite). Held firmly (centre) and smiling tensely for the occasion, more often than not sitters found themselves at the end of the session with a portrait 'in which self-esteem does not always fare well'. The procedure nevertheless retained an element of magic, mocked by many caricaturists, including Daumier (above).

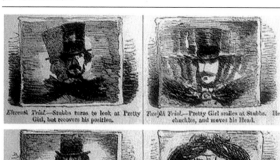

*Eleventh Trial.—Stubbs turns to look at Pretty Girl, but recovers his position.*

*Twelfth Trial.—Pretty Girl smiles at Stubbs. He chuckles, and moves his Head.*

*Thirteenth Trial.—Stubbs arranges his Cravat to Captivate Pretty Girl.*

*Fourteenth Trial.—Pretty Girl goes away. Stubbs begins to grow tired, and Yawns.*

Published in 1856, this American cartoon (left) tells of the misadventures of a certain Mr Bonaparte Stubbs, who, in the absence of the photographer, is forced to have his portrait taken by his assistant. The result does not live up to expectations, as the sitter moved and the photograph is off centre and out of focus. It is only with the return of the photographer and at the sixteenth attempt that the operation is a success!

Frenchman Antoine Claudet claimed to have produced 1800 plates between June 1841 and June 1842. In Paris, in 1849 alone, Vaillet mentions 2000 portraits, while Philippe Derussy claims to have created 12,000 daguerreotypes in three years. The cost of these portraits varied according to the fame of the photographer, the location and the format of the images: in London in the early 1840s Claudet, who imported his plates from France, sold his for one pound and three shillings, that is to say a little more than the weekly salary of an office worker. In Paris ten years later, Vaillat sold his for ten francs. By the end of the 1840s the daguerreotype portrait had become accessible to most people, even the middle classes.

### The success of the daguerreotype

However, it was in the United States that the daguerreotype really thrived, on an entirely different scale to its progress in Europe. A new, transportable and scientific process in a young country where mobility was great and any artistic tradition non-existent, its novelty and precision made an impression, particularly in the realm of the portrait, giving rise to numerous amateurs and a proliferation of the most luxurious studios: Southworth and Hawes in Boston, Robert Cornelius in

Ridicule of this kind was common in the literature of the period. In *La Légende du daguerréotype*, the critic Champfleury describes an imaginary portrait session during which the sitter gradually vanishes, at the same rate as the fruitless attempts: 'The more the artist aimed at perfection, the more the gentleman became worried: he felt as though he were becoming immaterial.... Finally, the daguerreotypist had no sooner completed his sixty-ninth attempt than the chair on which the gentleman had been seated was completely empty.... Nothing could be heard in the studio but his voice!'

Philadelphia, or John Plumbe, whose photographic empire in the mid-1840s comprised no fewer than fifteen or so establishments all over the country…and who went bankrupt two years later. Among the studios in New York were those of Jeremiah Gurney, Matthew Brady, the Meade brothers or Fredericks and his 'Temple of Art'.

In 1853, there were more than one hundred daguerreotype studios in existence, producing three million portraits. A town named Daguerreville, where the main activity was the production of plates, was founded on the banks of the Hudson River in the state of New York. A large proportion of this portrait production was also the work of itinerant photographers, often anonymous, accompanying the great migrations of population, such as the Californian gold rush of 1849.

In Boston in 1843, Albert Southworth, who shortly afterwards worked in collaboration with Josiah Hawes, opened what soon became the most sophisticated of the great American portrait studios, the aptly named 'Artist's Daguerreotype Rooms'. Their technical skill coupled with their sense of composition, partly derived from an artistic training – Hawes had been a miniaturist and portrait painter – made them, until their collaboration ceased in 1862, unequalled as daguerreotypists, stamping each of their creations with their own style. The two men mastered all types of portrait with great flair, particularly portraits of children (*Mrs J. Hawes and Alice* of c. 1840; left), one of the specialities of their studio. They were the only ones who, at the time, appeared capable of successfully producing images that were both natural and daring, thereby seemingly achieving the impossible, while confronted with a sitter who was constantly moving.

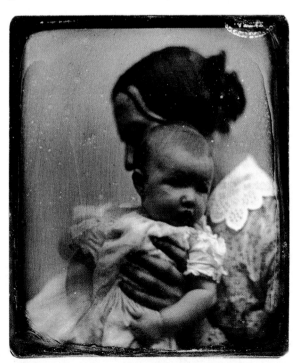

Although the portrait remained by far the largest category in which the daguerreotype was used, it was not limited to it. Views of architecture and landscapes were just as frequently produced, especially by amateur photographers: the painter Horace Vernet in Egypt in 1839; the architect Girault de Prangey in the Middle East from 1842 to 1843; the customs officer Jules Itier in the Far East; the diplomat Baron Gros in Colombia in 1842 and Athens in 1850; the German Adolph Schaffer in Java in 1842; and the writer John Ruskin in Italy and in the Alps in the same year.... In 1843, the architect Félix Duban commissioned some daguerreotypes from Hippolyte Bayard that documented the restoration of the Chateau de Blois; Viollet-le-Duc did the same for Notre-Dame.

Scientists were not to be outdone, especially in France and the United States: in fields as diverse as medicine (successes in microscopic photography from 1839 to 1840 by Alfred Donné in Paris and John Draper in New York, images of surgical operations in Boston around 1847), ethnography (skulls and 'living examples' by the Bisson brothers on behalf of the phrenologist Dumoutier in 1842), or astronomy (eclipse of the sun by the German Berkowski in 1842, daguerreotype of the sun at the Paris observatory in 1845, numerous images of the moon at Harvard's observatory from 1850 onwards) the precision of the daguerreotype came to the fore.

The diplomat and amateur photographer Baron Gros bequeathed a series of views taken during his missions to Bogota, London or Athens (detail of a frieze from the Parthenon, 1850; above). During the same period, astronomers and doctors were able to fix images created with the aid of a telescope or a microscope in the camera obscura, as in the image below.

### The calotype in Great Britain

At the beginning of the 1840s in this respect, Fox Talbot's process on paper was still far from being able to compete. Producing rather blurred images in sepia tones, consisting of blocks rather than lines, with strong contrasts and few half-tones, it still seemed unsuitable for commercial use, especially for portraits. In February 1841, Fox Talbot announced

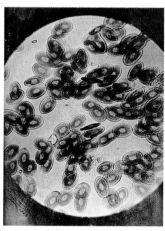

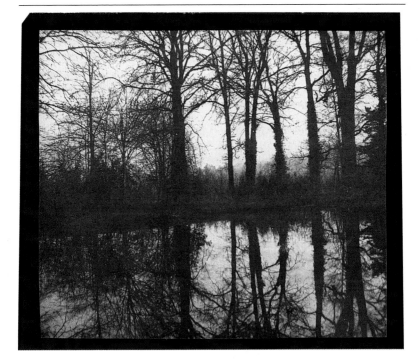

an exposure time of one minute as something remarkable, when certain daguerreotype portraits were already being executed in a few seconds. The numerous patents he had registered constituted an added obstacle to its development.

Some individuals took up the challenge nevertheless: Henry Collen, a painter of miniatures, was the first to obtain from the master the right to use his process. In 1841 he opened a portrait studio. In the following year he sold only two hundred prints and his annual turnover was only slightly greater than the daily one of a studio such as Beard's or Claudet's! The latter, however, soon followed in his footsteps and met with similar failure, resulting in his abandoning the process in 1847.

The commercial failure of the calotype portrait confined it to various other uses: outdoor or travel

In May 1840, in a list of subjects to be treated in calotype, Fox Talbot noted 'trees in a pond'. It was probably some time later, in the winter of 1841–2, that he produced this image (above) on his country estate, Lacock Abbey. A great inventor, Fox Talbot was also highly skilled at composing images. The theme of reflections on water, which he introduced here, soon became commonplace in photography.

photography, still life.… In Great Britain in the 1840s, the few calotypists were therefore amateurs, often those close to Fox Talbot himself: scholars, such as Sir John Herschel, distant cousins living in Wales, like John Dillwyn and Thereza Llewelyn, or other relations like Richard Calvert Jones or the Reverend Bridges. In sociological terms, these early British calotypists formed a category that was reasonably homogenous, well educated, interested in the sciences as well as the arts and with enough time and money to devote themselves to their hobby. They were members of various learned societies: the Society of Arts, Society of Antiquaries, Astronomical Society, Linnean Society. The subjects they favoured evoked a Britain that was rural and Gothic, stemming directly from the Romantic print.

In the second half of the 1850s, they were joined by a new generation – John Shaw Smith, Sir William Newton, Benjamin Brecknell Turner, Roger Fenton. In 1847 the Calotype Society, the world's first photographic society, was founded.

It was in Scotland, however, where it was free from restrictions, that Fox Talbot's process flourished between 1840 and 1850. In 1840 in St Andrews, not far from Edinburgh, a circle of amateur calotypists formed around the physicist Sir David Brewster, a friend of Fox Talbot.

In 1842, one of this group, a young engineer named Robert Adamson, opened a portrait studio in Edinburgh before joining forces with the history painter David Octavius Hill. During the five years in which they worked together, they created more than 2500 images, genre scenes, an admirable documentary on the fishermen of Newhaven, landscapes and views of Edinburgh and St Andrews, reproductions of works of art and antiques and, above all, hundreds of portraits from scientific, artistic, political and religious circles in Scotland.

### The calotype in France

Confined to Great Britain during the first half of the 1840s, Fox Talbot's invention gradually took root on

The alliance between technique and art is nowhere better embodied than in the work carried out by the young chemist Robert Adamson and the history painter David Octavius Hill. The latter, initially sceptical as far as photography was concerned, was nevertheless won over in 1843: wishing to paint a group portrait of the four hundred members of the Church of Scotland, he turned to Adamson to provide him with their photographic portraits. This collaboration was soon transformed into a lasting association, interrupted suddenly in 1848 by Adamson's death.

Their most astonishing work still remains the series of images taken between 1843 and 1847 in the fishing village of Newhaven (opposite), intended for a book that never saw the light of day: a real photographic reportage, this collection of almost one hundred and fifty images, presented at the Royal Scottish Academy in Edinburgh and subsequently at the Great Exhibition in 1851, was greeted by public and critical acclaim.

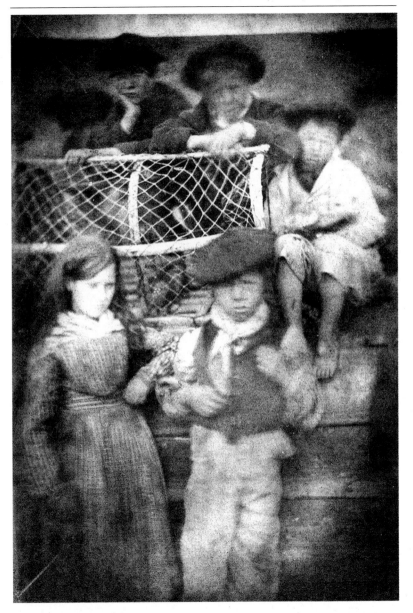

Sir John Herschel was responsible for coining the terms 'negative' and 'positive', adopted by Fox Talbot for his process. The majority of photographs on paper at the time had been sensitive to the intrinsic qualities of the negative, the reversal of values conferring upon the image a poetic, even dreamlike quality.

In the 1850s, with very few exceptions, the negative was the same size as the final print: the print was realized by contact, the two sheets being superimposed in a frame exposed to the light. The choice of negative paper proved to be essential: it had to be free from imperfections in order to achieve a uniform sensitization. Often, a simple sheet of writing paper sufficed. From the end of the 1840s, Le Gray introduced an important innovation, advocating that the paper be coated with wax before use: the 'waxed paper' negative meant sharper definition could be obtained and exposure times reduced. Paper negatives from this period differ greatly in tone, ranging from black and white to yellow and black via shades of brown or sepia (Fox Talbot's *The Haystack* of 1844; left), depending on the sensitizers and the fixing substances used.

the Continent from 1847 and, in one of the ironies of history, in Daguerre's native land particularly. Until then, the advocates of paper were few and far between in France: in Paris, Hippolyte Bayard continued to practise his process for a time. Following several vain attempts to gain recognition for it in official circles, he abandoned it and adopted Fox Talbot's process: views of Paris, still-lifes, self-portraits and portraits of his relatives formed the core of his production. During the same period in Normandy, several local notables, such as Humbert de Molard and Alphonse de Brébisson, also showed a lively interest in the process, although it was used extremely rarely.

In 1844, Louis-Désiré Blanquart-Evrard, a cloth manufacturer from Lille, set about improving the process developed by Fox Talbot, for which he seems to have acquired the formula fraudulently via an unknown intermediary. The improvements he made over the next few years were critical: faster, easier to develop, more reliable, the process was soon liberated from Fox Talbot's tutelage. However much Fox Talbot complained of piracy, there was little he could do: Blanquart-Evard's revised and improved calotype rapidly became established in France from 1847.

Some of its earliest exponents were painters or engravers by profession who appreciated its similarities on paper to the print: Charles Nègre, Henri Le Secq, Charles Marville, Gustave Le Gray. After studying art, Le Gray turned to photography in 1847 and, from 1849 to 1850, played a dominant role in the circle of Parisian calotypists because of his talent as a photographer as well as his

Easier to transport than the daguerreotype, the paper negative was greatly valued by travellers throughout the 1850s, and even later. The journey to Egypt provided some of the most beautiful and successful images of the period, taken by archaeologists (Devéria), artists (Bartholdi), amateurs (Greene) or professionals. The subjects favoured were sites, landscapes and monuments, while local inhabitants, as in the work of Ernest Benecke (below), were rarely represented.

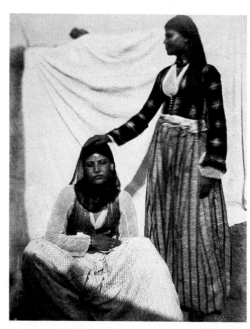

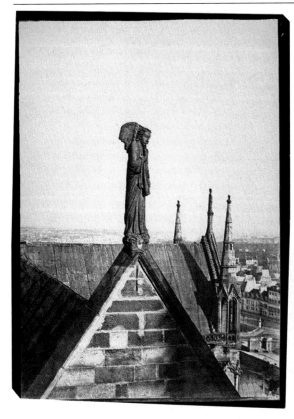

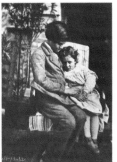

On the borderline between the fields of science and the arts, the new technique attracted both artists and scholars, such as the painter Charles Nègre and the chemist Victor Regnault, two of the most significant figures as far as photography on paper in France was concerned. Nègre was admired for his genre scenes, inspired by Romantic painting, and his views of architecture, particularly Gothic, as in the photograph of

skills as a teacher: many of the great French photographers of the period, Maxime Du Camp, Joseph Vigier, Alexis de Lagrange, passed through his studio at the Barrière de Clichy or else learnt from his successive manuals.

Groups were created and exchanges of ideas took place: on the outskirts of Paris, at the Sèvres porcelain factory, an enterprise was set up in 1851 at the instigation of its director, the great physicist Victor Regnault, and of the director of the painting studios, Louis Robert; and at spas in the Pyrenees by Mailand, Vigier and Maxwell-Lyte. During the same period, many calotypists gathered under the auspices of the

Notre-Dame de Paris (c. 1853; left), showing the angel of the Resurrection. Regnault, who was director of the Sèvres porcelain factory and the first president of the Société française de photographie, became interested in photography in 1843: he excelled in portraits of his relatives (his sons, c. 1854; above) and landscapes, particularly those around Sèvres.

Société héliographique, where amateur photographers, scientists and artists shared the common goal of spreading the new medium.

These exchanges soon occurred across national borders. In Rome, Italian, British and French artists and photographers met at the Caffè Greco, headed by the painter Giacomo Caneva and Comte Flachéron. Roger Fenton from England, former disciple of Gustave Le Gray and the Delaroche studio in Paris, introduced his process on waxed paper to England. In the summer of 1853, John Stewart and Victor Regnault photographed together in England.... Lighter and easier to handle than the heavy copper plates of the daguerreotype, the

process was particularly popular with travellers, even in the period up to the end of the 1850s: between 1843 and 1845, Richard Calvert Jones and the Reverend Bridges had taken several hundred calotypes of southern Italy, Malta and Greece; at the end of the 1840s, accompanied by Flaubert, Maxime Du Camp had used the process in Egypt while, during the same period, Alexis de Lagrange had taken it as far as India....

## The advent of collodion

At the Great Exhibition held in London in 1851, English photographers were struck by the vitality of

An unusual subject for photography at the time, this view of the public baths (below left) taken by Le Secq around 1852 to 1853, sums up the characteristics of the calotype perfectly: the sharp contrast between the rays of light and the shade, resulting from a technique still in its infancy, the static quality of the figures, inherent in the length of exposure time required, contributed greatly to the poetry of the image as a whole.

The Great Exhibition of 1851 provided the occasion for the first encounter between iron structures and photography, two new techniques then undergoing rapid development. Crystal Palace, a very photogenic structure with its enormous nave bathed in light, against which geometric shapes were silhouetted like pieces of lace, was the subject of many photographs (from c. 1854; opposite above). At the close of the Exhibition, photography was chosen by the jury in preference to lithography to illustrate its report: about one hundred and fifty images that illustrate the volumes (flint glass; opposite) glorified the inventions of the emergent industrialization.

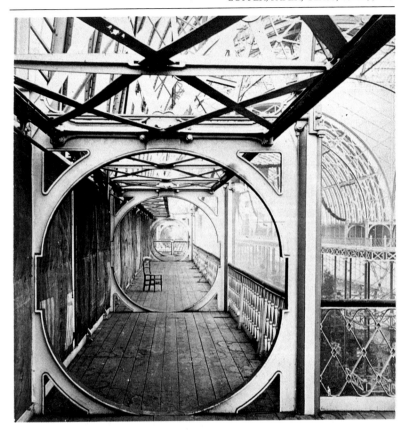

the French school of calotypists. Photography in all its guises was, furthermore, one of the main attractions of the Great Exhibition: its director, Henry Cole, was delighted that 'the most remarkable discovery of modern times – the art of photography' was represented, declaring that 'never before was there so rich a collection of photographic pictures brought together, the products of England, France, Austria and America'. The report on the Great Exhibition summed up the situation. While acknowledging

the superiority of the French calotype, the jury also praised the American daguerreotype. It recognized among the British a certain talent in a new technique perfected and presented the previous year by the sculptor Frederick Scott Archer: photographs taken from a glass negative coated with collodion.

The technique was destined for a great future. The use of a glass plate as a support for the negative

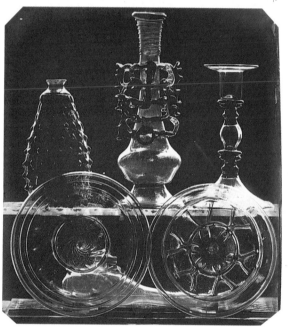

in conjunction with collodion – a solution of gun-cotton dissolved in a mixture of alcohol and ether – constituted a major development: the smooth surface of the glass helped to create an extremely accurate image with no grain, because, as a substance, collodion proved to be extremely fast. Combining the clarity of the daguerreotype and the ability to produce multiple images of the calotype, while requiring much lower exposure times, it was inevitable that the process would

In the 1840s, the Prussian Baron de Minutoli floated the idea of a museum of decorative arts. To represent his collection, he turned to photography, initially to the daguerreotype, then to collodion, with its unrivalled transparency. By the end of the 1850s, his catalogue filled seven volumes containing eight hundred photographs representing over eight thousand objects (15th-century Venetian glass; left). Fast and accurate, the new technique nevertheless required careful handling, particularly in the application of collodion on to the glass plate (above): this operation was 'extremely delicate and must be carried out with care' but became 'extremely easy once one gets into the habit', according to the instruction manuals of the time.

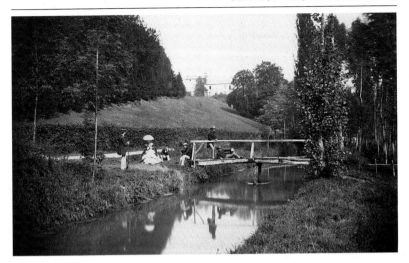

rapidly outshine its two rivals. Free from rights, as Scott Archer had offered his invention to the world without restriction, it was quickly taken up in Great Britain. The great French photographers, foremost among them Le Gray, were initially more reticent, eventually being won over around 1855. From this date, the technique, together with a new method of printing on paper coated with albumen, became virtually the sole one in use for more than twenty-five years, right up to the end of the 1870s.

In Europe during the 1850s, the daguerreotype was still used, but only in the field of portraiture and particularly outside the great capitals, while in the United States it continued to remain in vogue, before gradually falling out of favour after 1860.

As for the calotype, in 1852 under pressure from his friends, Fox Talbot finally agreed to relinquish his patent, with the exception of the realm of the commercial portrait: too late, however, to allow the process to become fashionable in England. The technique was already on its last legs. It continued to be practised until around 1855, before going into inexorable decline, merely surviving in a small way among amateurs until the 1860s.

The technique involving collodion had been extolled by Le Gray since 1850, but his formula was complicated and hence tricky to use. The following year, he showed little enthusiasm for Scott Archer's process, accusing him of being on the wrong track and affirming that 'the future of photography is entirely on paper'. Although they adopted the new technique, many of the great French photographers, such as Edouard Baldus, continued to employ the waxed paper negative. Once mastered, the technique showed sharp definition, often rivalling that on glass, as in this group portrait at the Château de la Faloise (above) from 1857.

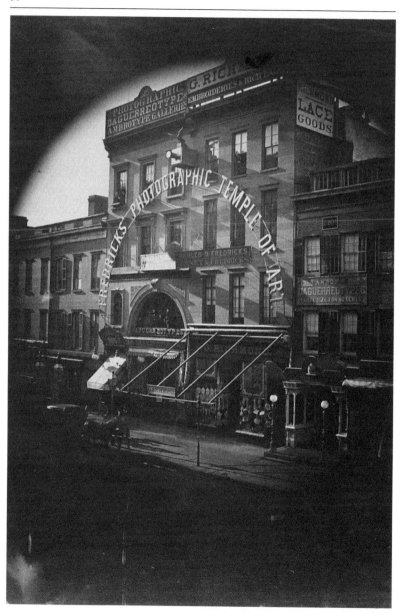

From the beginning of the 1850s, in Europe as in the United States, photography developed rapidly, progressing from the status of a cottage industry to a structure of semi-industrialization. The period was characterized by a considerable increase in the number of portrait studios, right up to the mid-1860s.

CHAPTER 3

# THE PHOTOGRAPHER'S STUDIO, 1845–75

Charles Fredericks' Photographic Temple of Art (opposite), one of the most popular on Broadway, proved capable of adapting to the times, passing from the daguerreotype to the ambrotype, after being the first to introduce the *carte de visite* into the United States. In his *Shower of Photographers* (1855; right), Nadar mocks the new fad and the proliferation of studios…while at the same time opening his own establishment.

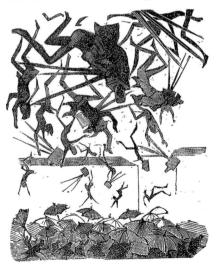

The 50 or so studios active at the end of the 1840s in Paris had increased to eight times this number by the end of the 1860s. In London, the number of establishments was 55 in 1856, 200 in 1861 and 284 only four years later. In the provinces, the increase was equally spectacular: from 17 studios in 1855, Manchester possessed 71 in 1865. Figures from the census carried out in England in 1851 showed 51 photographers, while ten years later the number of people earning their living from photography had risen to 2800.

## America

The advent of the new collodion method is not enough to explain this phenomenon: in the United States, where the process remained marginal throughout the 1850s, a sharp increase in activity also occurred. In 1858, New York, where the daguerreotype was essentially the only process used, had 200 studios, each producing an average of fifty images a day and with an annual turnover of two million dollars – an enormous sum for an industry that was still emerging.

Other factors can be found to explain it: favourable economic circumstances, due largely to the discovery of gold in California, saw fresh capital together with entrepreneurial businessmen interested in this new industry willing to back certain establishments financially. Portraiture using the collodion process meant that images were not only precise but could also be multiplied, thus offering the promise of considerable profits.

'The American daguerreotypists neglect nothing to attract and maintain public favour. They spend enormous sums on their studios, which are enchanted castles,' the journalist and critic Ernest Lacan was able to write in 1855, prior to describing the 'marbles carved into columns, the richly embroidered hangings, valuable paintings, soft carpets deadening the sound of footsteps,

A perfect example of how to build up a business gradually, Charles and Henry Meade started out in 1842 at Albany and then in Buffalo and subsequently opened several studios in New York from 1847, on Broadway (below) and in Brooklyn. At the height of their success, they employed a dozen assistants on Broadway alone. They were also among the pioneers of the calotype in the United States, from 1848 to 1849. Three years later, at the Great Exhibition held in London at Crystal Palace, they were well represented in the American section, which was rewarded for its excellent daguerreotypes.

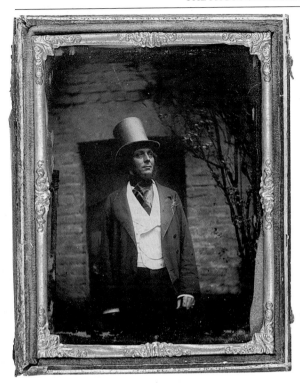

Invented in 1852 and often confused with the daguerreotype, the ambrotype (left; 1855–60) – 'the imperishable process' – was a collodion negative on glass, under-exposed at the moment it was taken and then chemically treated. The resulting image, on glass, was then displayed against a dark background on which it appeared as positive. In the portrait shown here the broken glass in the lower right-hand corner reveals the black card of the background.

In the last half of the 1850s, the ambrotype process, inexpensive and relatively simple to set up, rivalled the daguerreotype, also imitating the manner in which the daguerreotype was often displayed in a case. It did not remain fashionable for long and the two techniques were soon supplanted by the arrival of the new *carte de visite* format. In 1863, according to the *American Journal of Photography*, 'the expression ambrotype will soon become obsolete'. The process continued to be used, albeit marginally, until around 1880.

aviaries of birds from all over the world and rare plants' which populated American studios. Even before the invention of the *carte de visite*, photographic commerce in the daguerreotype portrait had reached almost industrial proportions in the United States by the end of the 1840s – which it did not do in Europe until the mid-1850s.

These 'temples of photography' were luxurious studios, created with the backing of external capital, the most famous being in the 1850s and 1860s, in addition to Fredericks, those of Jeremiah Gurney, Albert Southworth and Josiah Hawes, the Meade brothers and, in particular, Matthew Brady 'the last word in his profession'. The American portraitists did not turn to the collodion process until late, towards the

end of the 1850s. Brady, who always expressed his distaste for the *carte de visite* format, maintained that the advantage of the daguerreotype lay precisely in its 'unique character', that of being a 'work of art', less common than paper.

## 'Cartomania'

Following America's example, the number of great portrait studios multiplied in the capitals of Europe from the mid-1850s: in Paris, they went by the name of Mayer and Pierson, Nadar, Disdéri, and, later, Petit; in London, Mayall, Silvy, Elliott and Fry; in Munich, Locherer or Haenfstangel.... This phenomenon became even more evident following the advent of a new format in 1854, the so-called *carte de visite* photograph, which revolutionized the portrait market. It enjoyed enormous success for over ten years, representing the essence for millions of portraits sold throughout the world to such an extent that it led to the English coining the term 'cartomania'.

'Lower prices in order to increase considerably sales of products and, while popularizing photography, increase the total amount of profit': such were the recommendations to

Sometimes the studio was transformed into a stage set where the sitter-actors interpreted scenes from plays or tableaux-vivants (right).

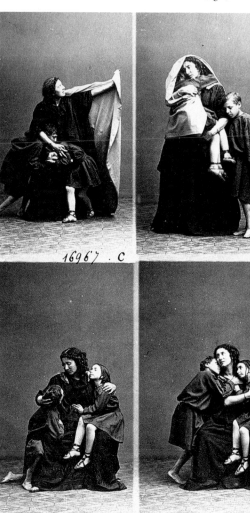

# GALERIE DES CONTEMPORAINS

### Portraits en pied photographiés par

# DISDÉRI

photographers issued in the report of the jury of the Exposition Universelle held in Paris in 1855. This was exactly what the photographer Disdéri, a native of Brest, did, patenting, in 1854, a new process, the portrait-card or *carte de visite* format: this consisted of creating, on a single collodion negative plate, four, six or eight views, thanks to a special frame or a camera with multiple lenses. The images obtained were small in size (10 × 6 cm; $3\frac{7}{8}$ × $2\frac{3}{8}$ in.) and glued on to a piece of card of the same format as a visiting card.

The reduction in the formats of the portrait allowed for a reduction in costs and economies of scale, making photography accessible to greater numbers: whereas in 1855, the price of a large portrait (approximately 18 × 24 cm; $7\frac{1}{8}$ × $9\frac{1}{2}$ in.) ranged from 25 to 125 francs depending on the photographer, images in the *carte de visite* format sold for around 1 franc each.

It was several years before the *carte de visite* became established, not really becoming fashionable in France until around 1858. In response to the new competition from Disdéri, most of the other studios soon found themselves forced to comply, sometimes against their will, as in the case of Nadar or Le Gray, often resulting in a standardized and stereotyped production.

In England, it was not really until Queen Victoria and her consort had also succumbed to this fashion that the new format truly took off. Between 1861 and 1867, three to four hundred million *cartes de visite* were sold each year. During the same period, the great photographer Camille Silvy claimed to have produced 850,000 *cartes de visite* for 17,000 different clients.

In 1860, Adolphe Eugène Disdéri opened his *Galerie des Contemporains* (advertisement in *Le Figaro*, 1860; top). For two francs a week, the subscriber received a *carte de visite* portrait of a celebrity together with a small plaque with a biography. By 1862, more than 120 had been published. The majority of those represented were actors or actresses. Disdéri produced several series with the great tragic actress Adélaïde Ristori, in roles and tableaux from her repertoire, including *Medea* (opposite). Before cutting, the plate provided an insight into the session.

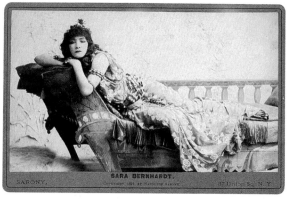

SARONY,  SARA BERNHARDT.  Copyright. 1891. by Napoleon Sarony.  37 Union Sq. N. Y.

The actress Sarah Bernhardt maintained that one of the main reasons for her visit to New York in 1880 was to be photographed by Napoléon Sarony (as she was in 1891 in the role of Cleopatra; left). For the first sitting, Sarony paid her the sum of 1500 dollars. He soon became one of the main photographers of the actress, publishing a number of portraits of her in album format (approximately 10 × 15 cm; $3\frac{7}{8} \times 5\frac{7}{8}$ in.). Appearing in the mid-1860s, this new format soon replaced the *carte de visite*, which dwindled in popularity.

## Galleries of celebrities

Two fundamental desires lay at the root of the 'portraituromania' so mocked by humorists at the end of the 1850s: firstly, to have one's own portrait taken and, secondly, to collect the portrait of others. As the advertisements in certain newspapers show, a huge traffic in exchanges soon emerged. Acquisitions, swaps, all were more often than not consigned to family albums specially created for the purpose: friends and relatives appeared side by side with the celebrities of the time – politicians, comedians, artists.

From the beginning of the 1850s, the trade in celebrity portraits became an extremely lucrative occupation, with most of the large studios devoting their efforts to it. Each photographer had his own speciality: Pierre Petit, the clergy; Nadar, bohemian Paris; Disdéri, high society and the *demi-monde*; while in England, Silvy specialized in the artistocracy and members of the court, and in America post-1860, Napoléon Sarony concentrated on the world of show business. While the man in the street might acquire several dozen copies of his portrait in the *carte de visite* format, those of celebrities might sell tens or even hundreds of thousands of copies: when Prince Albert, Queen Victoria's consort, died in December 1861, over 70,000 portraits sold within a week.... In 1867, the English photographer William Downey claimed to

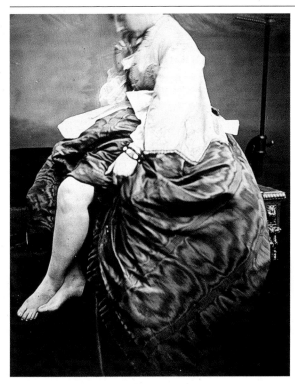

Mistress of Napoleon III and considered the most beautiful woman of her time, the Comtesse de Castiglione posed for the great studio photographer Pierre-Louis Pierson hundreds of times from 1856. Owing to the flamboyant nature and exaggerated vanity of the sitter, the results are strangely out of keeping with the studio photographs of the period, as in the study with bare legs shown here (1861–7; left), in which, given the audacity of the subject matter, the model has uncharacteristically chosen to conceal her identity.

Drawing from his gallery of portraits of celebrities, Disdéri perfected and patented in 1863 the technique of the 'mosaic' card (opposite below). This composite and fanciful assembly of portraits, which were cut out, stuck and then re-photographed, allowed him to recycle a large part of his collection. Cards with subject matter of all types were soon issuing from his studio: actors and actresses, politicians, dancers' legs or, as in the example illustrated here, portraits of the imperial family.

have sold 300,000 likenesses of the highly popular Princess of Wales. Whereas the portrait of an ordinary person would cost between 1 and 3 dollars, a portrait of a celebrity could rise to 25 dollars.

In this respect, the vogue for the *carte de visite* format simply magnified a phenomenon already in existence, the taste for galleries of public figures, already visible in the United States from the mid-1840s. Edward Anthony, a pupil of Morse, created a 'National Daguerrean Gallery' of prominent people in Washington, D. C. In 1850, Brady's *Gallery of Illustrious Americans* was a publication consisting of a lithographic portrait and a biography, in accordance with a formula subsequently taken up in Europe for innumerable galleries of contemporary figures in the period between

1850 and 1870: Locherer published his *Photographisches Album der Zeitgenossen* in Munich between 1850 and 1863; in Paris from 1853, Théophile Sylvestre published his *Histoire des artistes vivants*, consisting of photographs accompanied by biographical notes.

Faced with this increased competition, each studio sought to attract the most famous celebrities and, if possible, to obtain exclusive rights over them, in return for a fee. Whereas Brady, in the 1840s, had been happy to give them one of the daguerreotype portraits taken during the sitting, retaining the right to sell the others, from the 1860s, celebrities often demanded a payment. In 1867, while on tour in the United States, Charles Dickens refused to sit for Jeremiah Gurney unless he was paid. The news caused a sensation among artists who, in their turn, frequently demanded to be able to share the profits resulting from the sale of their portraits.

### The photographer's studio

Across the Atlantic, the great studios also maintained an ostentatious luxury, in keeping with the taste of the fashionable press: the visit to the studio of the great photographer became commonplace in the magazines of the period between 1850 and 1870. Intended for the affluent middle-classes, the most opulent studios were to be found on the new thoroughfares of the great capitals: in Paris, around the Opéra; in London, on Regent Street, where forty studios were situated in the

The vogue for photographic portraits rapidly spread among high society, as this outfit worn in 1864 to a costume ball in Paris testifies (opposite below): wearing a camera on her head, this young woman represents 'Photography'. Published in *Les Modes parisiennes*, the costume was widely copied and was later modified.

mid-1860s; in New York, on Broadway. Branches were set up in the places frequented by fashionable society and the *demi-monde*: the Bois de Boulogne in Paris, where, in the 1860s, Disdéri and then Nadar opened studios specializing in 'equestrian photography'; or in fashionable resorts like Baden, where during the high season Carjat had a studio. The glass cage nestling below the roofs typical of the 1840s was a thing of the past. Instead of interminable stairs to climb, studios were now situated on the grander lower floors, where marble vied with crystal. Sitters were accommodated in a room resembling a salon rather than a dentist's waiting room. While they waited, they could leaf through albums containing the studio's latest creations, selecting a pose. They could admire

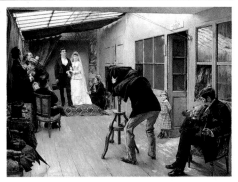

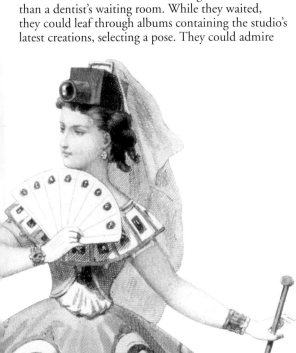

In 1860, Nadar opened a 'veritable Crystal Palace' on the Boulevard des Capucines, in a building previously occupied by Le Gray (opposite). His scarlet signature is emblazoned across the façade. Its ostentatiously luxurious interior was filled with works of art and knick-knacks. Nadar had fifty employees under his command and demanding shareholders: the head of the studio was little more than a foreigner in his own realm, soon cursing this 'idiot's profession, so insipid after thirteen years of work'. This method of production was in strong contrast to the more intimate and homely atmosphere of the provincial photographer's studio, immortalized in 1879 by Dagnan-Bouveret, a painter from Lyons, in his *Wedding at the Photographer's* (above).

a gallery of paintings, enjoy the facilities of a library, or even, for gentlemen, of a smoking or billiard room. Sometimes, a conservatory or a garden, as in the case of Nadar's first studio, completed the picture. Over this kingdom reigned the master of the premises: from the 1850s, the great studio photographer became a celebrity.

In the early 1860s, Disdéri personified a true Parisian type, the studio photographer, producing a portrait per minute. Journalists flocked to his studio: his silhouette, characterized by his long beard and his 'black coat with blue buttons fastened with a wide leather belt' (in a caricature of 1863; below), became legendary, as did his phrase 'Hold still!', which he is credited with inventing and which punctuated each of his sittings.

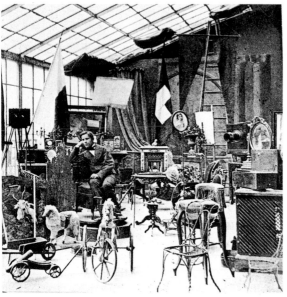

Caricaturists seized upon these figures, mocking the extravagant and slightly bohemian dress they cultivated: Disdéri's Russian tunic and boots, Petit's dishevelled hair, all part of a business and advertising strategy of 'being an artist'. In Nadar's studio on the Boulevard des Capucines, everything was red, from floor to ceiling, right down to the great man's jacket. In the 1870s, Sarony brought this practice to a height, becoming 'one of the attractions of Broadway: he strolled along with the rolling gait of a sailor, saluting to left and right as though everybody knew him'.

## Exposure time

The master of the premises officiated when the sitter was someone well known, but more often than not, he delegated this task to his assistants. The studio itself frequently mimicked that of a painter to the point of caricature. The light often entered through a north-facing window. Artificial light was rarely used until the end of the century. Exposure times always varied, but could still be several seconds. The negatives used, which were not sensitive to all the colours of the spectrum, led to certain types of clothing being recommended. Beige or sombre clothes were preferable to dazzling white. Maull and Polyblank, photographers in the West End of London, advised their clients 'black silks and satins are most suitable for ladies' dresses. The colours to be avoided are white, light blue and pale pink'.

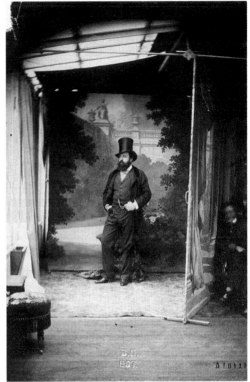

Looking behind the scenes, portraits of photographers in their studios often emphasize the theatrical nature of the photographic process. In this self-portrait taken in his apartment in the Place Vendôme (above), Olympe Aguado highlights the *trompe-l'œil* décor by a clever use of framing, while the Swiss photographer Boissonnas poses amongst his studio accessories (opposite).

Compared with the studios of the early daguerreotypists, apparatus and settings had become considerably more sophisticated. To the ubiquitous pedestal table were added other pieces of furniture – columns, cardboard balustrades and hangings – inherited from the ceremonial portrait. Reproduction furniture was also available. In 1878, a manufacturer of studio accessories boasted of the merits of his latest creation: 'a piece of furniture in sculpted oak which can be transformed at will into a sideboard, a fireplace, piano, desk, or prie-dieu'. These pieces of furniture fulfilled a dual purpose, decorative and practical,

ensuring the model held the pose during the sitting. The widespread use of carefully concealed headrests continued, nevertheless, throughout the 1850s and even 1860s.

From the early 1850s, photographers increasingly made use of painted backgrounds: domestic (middle-class interiors), rural (woods), summery (seaside), gothic (thick castle walls), the possibilities were endless, depending on the country. Hence the Canadian photographer Notman became a specialist in scenes from the Frozen North...reconstructed in the studio. Plants or stuffed animals were also available to add an exotic touch. Sometimes the session really did take place in the open air. Thus William Savage, a photographer based in Winchester, placed at his clients' disposal 'surrounding grounds laid out entirely for photography: equestrian groups, cricketing groups, croquet groups, archery groups and boating groups with appropriate accessories ...a large pool of water on which is a beautiful pair oared boat'.

*Farben-Ausführungen. Aquarell*

*Verderbliche Wirkung des Zinnobers.*   **1857**   *Ausführung ohne Zinnober.*

### Behind the scenes

The exposure time was, however, merely the most visible part of the portraitist's work. Behind the scenes, the great establishments operated a strict division of tasks, requiring an astonishing number of employees, both before and after the image had been taken: chemists to prepare the negatives; printers to develop the proofs; labourers and young children to colour and stick the prints; in addition to those involved in administration

Signifying a break from the two-tone monotony of prints, the use of colour on photographs, whether simply to highlight or entirely to repaint, was very much in vogue, not only for the realism it imparted to the image but also for its plastic qualities. The technique is illustrated here by Hermann Kröne of Dresden, who, in his 'museum of photography' – a collection of many plates – described the practice of the new medium (above).

and marketing. At the height of the vogue for *cartes de visite*, in his studio on the Boulevard des Capucines, Nadar employed about fifty people, while Disdéri had over eighty; in addition to his studio in the centre of town, the one in the Bois de Boulogne and the branch in London, he had a printing studio and one specializing in framing, as well as various offshoots in the suburbs.

To satisfy the requirements of the client, it was often necessary to eliminate any defects and to carry out some retouching. There were two sorts of retouching: 'technical', intended to hide imperfections on the negative with slightly gummed India ink, or 'artistic', often on the print itself and aimed, with the aid of pencils, brushes, Indian ink, watercolours or pastels, at radically altering it – more often than not to render more 'pictorial'. Retouching sometimes meant completely repainting the print, or adding coloured highlights in certain parts of the image. The painstaking task of colouring the photographs was often carried out by women. Some retouchers were considered on a par with true artists, even jointly signing the finished print.

These two images (below) provide a view behind the scenes in the studio – a subject that rarely appears in the photographs of the period. Certain processes can clearly be seen, including the drying and cutting of the prints (below left), or the use of the printing frame to obtain the proofs and the task of retouching with ink and brush (below right). It is interesting to note that many of the workers are extremely young or else women.

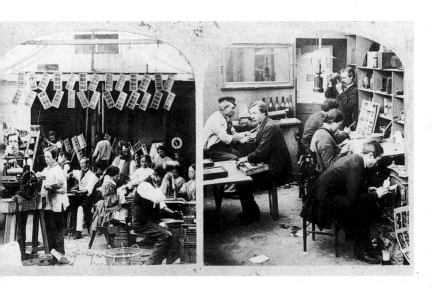

The declared champion of the artistic photograph, Henri de la Blanchère illustrated in 1859 the work of Jules Janin devoted to the actress Rachel with ten photographs: to the initial portraits taken in the studio of the actress in the various roles of her repertoire, painted and drawn backgrounds were subsequently added by hand, resulting in a hybrid, halfway between drawing and photography (right and opposite).

In 1855, a lively debate on the subject of retouching occurred within the Société française de photographie between the critic Paul Périer and the photographer Eugène Durieu. Périer defended the practice in the name of art: 'Let me touch my negatives and even my positives if I can improve them and embellish them even one degree.' Durieu was opposed to manual intervention of any description, as 'using a paintbrush to help photography under the pretext of introducing art into it actually excludes the art of photography.... One will merely obtain something indefinable, which at most would be a curiosity'.

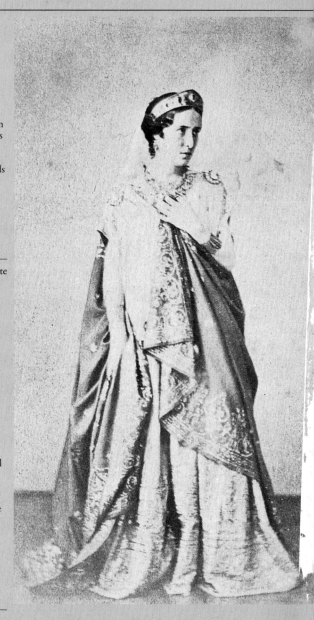

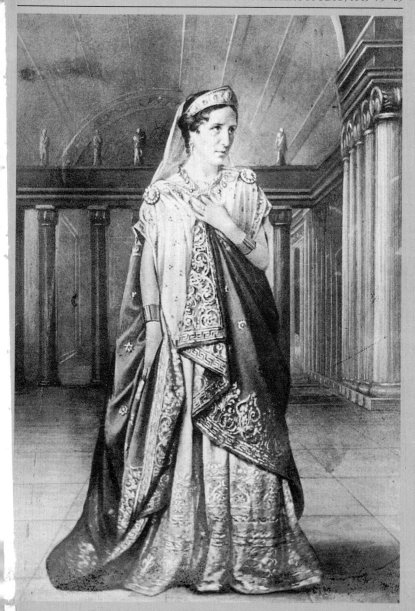

The question of retouching naturally caused a stir in artistic circles: 'force of circumstance' in the eyes of some, artistic addition in the eyes of others. Universally practised, it continued to be disparaged, even by those who carried it out. Nadar brought the debate to the fore again, referring to it in his memoirs as 'excellent and loathsome'. He himself made full use of it during the 1850s, and even more so as the years passed, coming into line with the tastes of the market. In the 1870s, a corner of the reception room in his studio in the Rue d'Anjou was occupied by an artist-retoucher who practised his art in full view of everyone: from its beginnings as a shameful practice, retouching had finally won acclaim.

### Photographer, a profession?

Despite the astonishing social success of some photographers and the undeniable artistic talent of others, the profession continued to be regarded with disparagement. As Flaubert indignantly exclaimed to Maxime Du Camp: 'The *Légion d'Honneur* for a photographer!' The photographer was still often

**DENTISTRY**
—AND—
**DAGUERREOTYPING.**

**Corner of Oregon and Lane Sts.**
(Opposite the M. E. Church.)

**WILLIS & HAMILTON,**

While the daguerreotypist's studio was sometimes compared with the dentist's surgery, in the early days of photography, there were occasions in which the two professions did indeed go hand in hand (an American advertisement from 1859; above). Equally numerous when the medium first appeared, itinerant photographers travelled from town to town, keeping pace with local fairs and public holidays, improvising makeshift studios, often with the help of a curtain in the guise of background. Despite the development of photography in the studio, the practice lasted throughout the century, as this image taken by John Thomson in London during the 1870s shows (opposite).

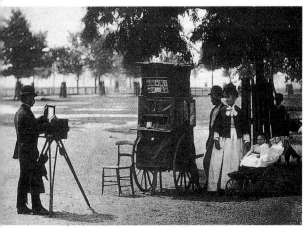

perceived as a dubious individual, at best a failed artist, at worst a shady character, so the profession attracted candidates from the most varied backgrounds: dentists, watchmakers, painters, miniaturists, opticians, engineers.... 'Anyone already classified or waiting to be classified set up as a photographer: the apprentice clerk who has somewhat neglected to hand in the day's takings on time, the *café-concert* tenor who has lost his voice, the concierge suffering from artistic nostalgia,' quipped Nadar in his memoirs. Often, this false *métier* did not last long: 'Today, you'll find the Yankee practising the daguerreotype, tomorrow he'll be a painter, a day later, he'll be running a grocer's shop.'

The reason that the profession attracted so many spontaneous amateurs undoubtedly stemmed from the fact that, in the 1850s, it was seen to represent a future in which huge fortunes could be made quickly. While this was true only in a very limited number of cases, the wealth and status of these photographer-company managers, the leitmotif of the press of the time, merits serious consideration. The great Parisian studios were, for the most part, founded with the help of external capital, collected in the guise of a joint-stock companies, at the heart of which the photographer was at best a major shareholder, but often merely a salaried employee,

In 1852, while in exile in Jersey, Victor Hugo contemplated publishing an album on the Channel Islands, illustrated by photographs taken by his sons and his pupil Auguste Vacquerie. 'It is the photographic revolution we want to stir up, in the meantime,' he wrote on this occasion to his publisher Hetzel. While he already sensed that sooner or later the photograph was destined to replace the 'heavy and awkward lithograph', Hugo also saw in the new technique, even practised by amateurs at the beginning of the 1850s, a potential and not inconsiderable source of income, even contemplating selling his portraits one by one. Although the planned publication never saw the light of day, over three hundred images – essentially portraits – were actually produced in 1855, sent to relatives, put into albums (opposite) or stuck into his own collections of poetry.

like Le Gray or Nadar after 1860. The profession was not without risk and bankruptcies were common, even among the best-known photographers: Brady, Mayer and Pierson, Nadar and Le Gray to name only the most obvious. Disdéri himself, following a reversal in fortunes, died in poverty in Nice in 1884.

Industrialization and the difficulties of the profession lay behind the creation of the first professional organizations. In France, the Union photographique was founded in 1859, the Chambre syndicale de la photographie in 1862, followed by the Société de secours mutuels des employés en photographie in 1872. The success of certain photographers relegated a multitude of anonymous ones to the background, working in studios more modest in

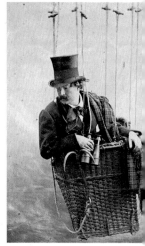

size. In Paris in the mid-1860s, the number of studios employing more than ten people was less than ten per cent. Small, family-run concerns, with one or two employees, were still more numerous by far during this period, even though their annual turnover was quite low.

The profession was thus much more diverse and varied than certain contemporary accounts would suggest. There were, especially in the provinces, a certain number of women who helped their husband, or even took over the studio upon his death. In the period between 1850 and 1880, many itinerant photographers still existed, setting up their apparatus at local fairs, in public squares and arousing the anger of 'established' photographers. Another indication that the term photographer portraitist was far from representing a homogeneous reality.

When the caricaturist Nadar turned to photography in 1854, his first attempt was a masterstroke: the series of facial expressions of the mime artist Deburau (opposite) made with his brother Adrien was awarded a gold medal at the Exposition universelle in 1855. Nadar then set up on his own in the Rue St-Lazare, producing portraits of bohemian Paris, his great genius shining through particularly in the composition. This heady period lasted for several years before disillusionment set in. Nadar lost interest in photography, attracted instead by what became his great passion during the 1860s: the hot-air balloon (above).

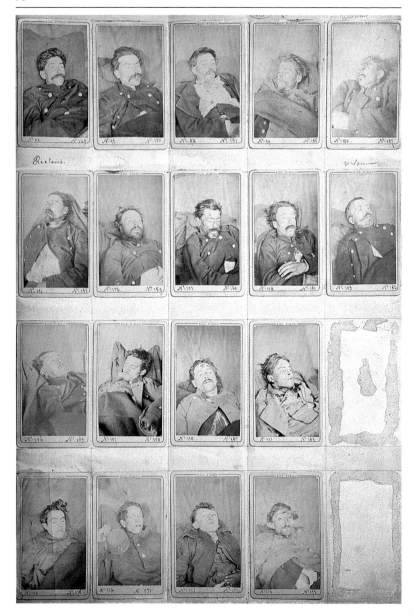

The Great Exhibition of 1851 had marked the apogee of the daguerreotype and the calotype. The subsequent one, held in 1855, witnessed the arrival of collodion. From then on photography established itself as a medium for recording facts in a constantly expanding number of areas of human activity: industrial, judicial, scientific....

CHAPTER 4

# 1855–80: AN OBJECTIVE MEDIUM?

Outside the studio, photography even reached the battlefield. Left: the photographic van used by Roger Fenton during the Crimean War. Opposite: portraits of national guards killed in combat during the Paris Commune.

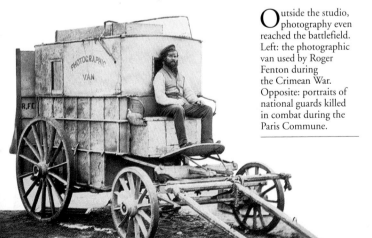

Endowed by then with a certain technical maturity, photography during this period gradually supplanted all other techniques used to reproduce images until then – drawing, print or plaster cast. Relative speed of execution, the accuracy of the resulting image, the 'objectivity' of a mechanical process all combined to make it, in the eyes of the public, a valuable aid – document, testimony, even evidence of an 'irrefutable brutality', to reiterate the words of the photographer-archaeologist Auguste Salzmann.

## Growing interest from public institutions

From the beginning of the 1850s, there was an increase in official commissions. The phenomenon was particularly evident in France, a country in which the State enjoyed a considerable amount of power. Photography of architecture appears to have been one of the fields favoured by these early surveys: in 1851, the Commission des monuments historiques invited

In France, the interest shown in photography by the authorities during the Second Empire was particularly evident in the commissioning of reportages: on the military reviews in the camp at Châlons (Le Gray, 1857) or the floods in the Rhone valley (above), taken by Baldus in the difficult conditions of the summer of 1856. A large number of photographers were also granted the title of 'photographer to the Emperor'.

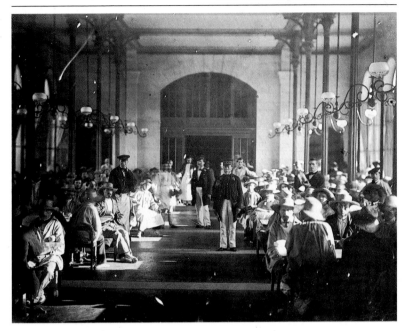

five photographers (Baldus, Bayard, Le Gray, Le Secq and Mestral) to make some photographic records of the national heritage, subsequently known as the 'heliographic survey'. A year earlier in Brussels, the photographer Guillaume Claine had been asked by the government to 'form a collection of a certain number of Belgian monuments'.

In France, this tendency was stepped up during the Second Empire: the imperial household and numerous other ministries funded, directly or indirectly, various selective projects. The Emperor himself took an interest in photography, commissioning documentaries, many of which are among the most astonishing photographic successes of the period. In England, although the backing of the State was more indirect, both Queen Victoria and Prince Albert demonstrated a real passion for the medium, playing a significant role as patrons.

Lastly, in the United States, particularly after the Civil War, the number of government-sponsored expeditions

It is probable that Charles Nègre's reportage (1858–9; above) on the imperial retirement home at Vincennes – founded on the instigation of Napoleon III – was the result of an official commission. Exhibited at the Société française de photographie, the photographs, with the exception, strangely, of some such as this magnificent view of the canteen, were collected in various albums, then sent or presented to certain key figures, as was normal practice at the time.

for the exploration of the West increased rapidly, with photography being called on to play a dual role, both documentary and propagandist. These campaigns focused as much on the terrain (Hayden Geological Survey, 1870) as on the landscape and its inhabitants (surveys by the Bureau of American Ethnology): most of the photographers (William H. Jackson, Timothy O'Sullivan, Carleton Watkins, Andrew Russell, William Bell, John K. Hillers, Eadweard Muybridge) had learnt their profession during the Civil War and marketed their own images, which were also used by the government.

## Photography, the police and the army

The interest of the public institutions was particularly evident in the realms of the police and the army, where the authorities were very quick to realize photography's potential contribution: in 1842, the Brandt brothers took daguerreotype portraits of the inmates of a prison in Brussels, and there was already talk of photography being used to create identification documents. During the 1850s in Birmingham, the British police also employed daguerreotype portraits. In New York, daguerreotypes of wanted men were hung side by side on boards erected for this purpose in police stations. After the *carte de visite* format was introduced and as the photograph on paper became more common, these practices were more widely used.

More reliable, with unlimited circulation, easily carried, photography was

In 1856, advocating the use of photography by the French police, the critic Ernest Lacan wrote: 'Which criminal could escape the watchful eye of the police? Although he might escape the walls where he is serving his punishment; although once free, he might break the decree ordering him to be confined, his portrait is in the hands of the authorities. He cannot escape: he, himself, will be forced to identify himself in this incriminating image'. Shortly afterwards, the first judicial identification portraits were produced (below left, two portraits of the murderers sentenced for the Ariège affair in 1864) based on the *carte de visite* so popular in the portrait studios of the time and adopting the same format. During this period the first portraits of famous criminals also appeared on the market.

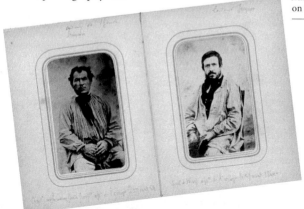

frequently exploited for identification purposes from the 1860s. After the Paris Commune (1871), individual suspects were systematically photographed in the prisons around Paris, a selective process at the origin of the first photographic shoot carried out by the police authorities, at the beginning of the 1870s. The use of standardized shots did not come into being until the 1880s, with Alphonse Bertillon's anthropometrical system.

In 1867, Timothy O'Sullivan set off on the first great expedition to the American West, the so-called 'Fortieth Parallel Survey', where he produced numerous images, including this view in Nevada (1868; below). Although he did

The army was not to be outdone: during the Crimean War (1853–6), the British had arranged for photographers to be sent to document the battlefields. On the other side of the Atlantic, the American Civil War (1861–5) witnessed for the first time a soldier, Andrew Russell, a captain in the Northern army, being officially charged with covering the conflict from a photographic point of view. In the 1860s, photography was, however, used to keep a record of ballistic tests, or else in the preparation of topographical surveys and the drawing up of plans. During the siege of Paris in 1870, the microphotograph was used to send information via carrier pigeon.

not use the large-scale glass negatives (the so-called 'mammoth') adopted by some photographers, his images nevertheless display the same intense excitement before the vast spaces and unspoilt nature. The work by some of his colleagues – such as Watkins at Yosemite – was responsible for the authorities creating the first national parks.

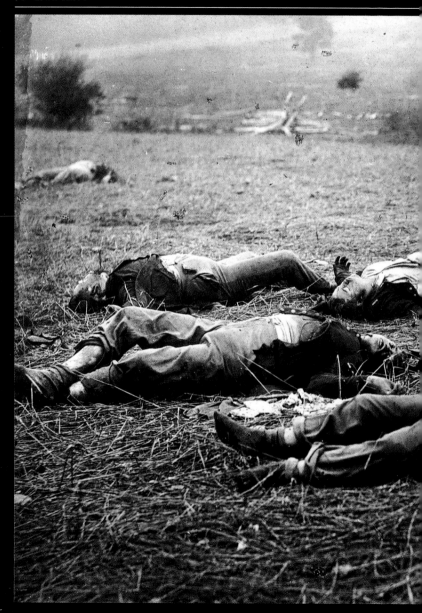

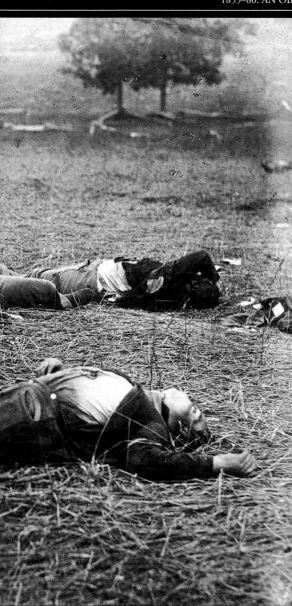

The Crimean War was the first conflict to be covered by photographers – the British Fenton and Robertson; the Frenchmen Langlois, Méhédin, Durand-Brager and Lassimonne; and the Romanian Szathmari – in a coherent fashion. Lengthy exposure times prevented any attempts to capture images of the combat, which were substituted by indirect evocation – pictures of ruins, battlefields devoid of corpses – or reassuring group portraits, such as this 'Entente Cordiale' by Fenton (1855; above).

The most complete coverage of a conflict during this period was that of the American Civil War: many photographers, including Matthew Brady, who obtained permission to follow the troops, Alexander Gardner and Timothy O'Sullivan (Gettysburg in 1863; left), produced thousands of images that 'brought the terrible reality of the war into every American home'.

## A tool for industry

During the 1850s, the world of commerce and industry also became aware of the significance of the new medium: various manufacturers and businesses resorted to it to keep track of their production, sometimes for promotional reasons, as, for example, from 1855 the Sèvres porcelain factory in France. It is undoubtedly, however, in the realm of architecture and industrial building that photography most closely accompanied nascent industrialization and the advent of iron and steam: already in the years between 1844 and 1849 the German Aloïs Locherer produced a reportage on the construction of the elements that constituted the 'Bavaria' monument, the first example of a photographic 'log book', describing each stage of a building. In England, the great metal constructions of the 1850s provided subject matter for photographic reportages – commissioned by architects or external patrons, whether Crystal Palace in 1851 and 1854 (Philip Delamotte, Robert Howlett and Joseph Cundall) or the steamship *Great Eastern* in 1857.

In 1857, for documentary purposes and on the initiative of *The Times* newspaper, Robert Howlett, a professional photographer, covered the building of the *Great Eastern* (opposite), the enormous steamship designed by Isambard Kingdom Brunel, one of the finest engineers of the era. There was great enthusiasm on the part of the public for this huge enterprise. Work on it had lasted for four years. A few weeks after the ship was launched, nine engravings based on Howlett's photographs appeared in the *Illustrated Times*.

Occasionally the collaboration between an architect or project manager and a photographer could also last for several years, particularly during lengthy campaigns of public works: as in the example of Edouard Baldus, covering the building site for the new Louvre between 1854 and 1857, or Charles Marville, employed by the Paris authorities for over a decade to immortalize the transformation of the capital. In Belgium, Edouard Fierlants carried out a similar task in Antwerp (1860) and then in Brussels (1862–4), as Adolphe Terris did in Marseilles for almost thirty years. Hippolyte Collard, 'photographer for the Department of Civil Engineering' during the Second Empire, made a speciality of works of art and building sites. Recognition of this practice came in 1864, with the foundation of an international society for architectural photography.

Among the most frequent users of photography at this time were the railway companies, who were going through a period of rapid expansion. Their interest in photography was primarily for promotional purposes. Between 1855 and 1859, Baldus covered the construction of railway lines running the length and breadth of France, from Boulogne to Paris, and then from Paris to Marseilles, immortalizing stations, new constructions and landscapes.

Already adopted during the 1840s by several architects to document building work and restoration, photography was subsequently added to the working drawings and log-books which served, day by day, to record progress on site. Thus, during the construction of the Opéra in Paris from 1867 to 1868, Charles Garnier commissioned photographs from Delmaet and Durandelle (opposite) to 'preserve a souvenir of the various building plans…every time that important changes occur on site'. They formed an impressive collection of dozens of images, although many of them did not appear in *Le Nouvel Opéra de Paris*, a book that Garnier published, since he preferred to entrust the task of illustrating his project to drawings, which he found more legible. Most of the photos published were reproductions of sculpted or painted decoration.

It was in the United States, however, that the phenomenon assumed the greatest proportions. After the Civil War, most of the railway companies drew upon the services of photographers, entrusted with highlighting their achievements as well as extolling the beauty of the territories passed through: Gardner in Kansas, on the initiative of the Kansas Pacific and the Union Pacific Railroad to follow the construction of the railway all the way to California (1867); Russell, a specialist in trains, who immortalized (1869) the historical meeting at Utah Promontory Point, where the railroads from the East and the West joined.

## A fragile aid to science

It was amongst scientists that photography was the greatest bearer of hope. In France, between 1852 and 1856, a doctor, Duchenne de Boulogne, embarked on a grammar of muscles illustrated with photographs. From the 1860s, the collodion process became increasingly widespread, the images obtained often

In 1868, the Union Pacific Railroad hired the photographer Andrew Russell to cover the construction of the railway, which, starting in Nebraska, headed towards California, crossing vast territories as yet unexplored. During three successive journeys, in 1868 and 1869, Russell produced a series of images (above) – nowadays considered classics – showing not only the men at work but also the landscapes they crossed. Some were collected in *The Great West Illustrated*, published by the company itself in 1869.

being used for educational purposes. In 1868, two doctors from St-Louis, Hardy and Montméja brought out the *Clinique photographique de l'hôpital St-Louis*, a book on diseases of the skin illustrated with photographs. The success of this initiative led logically to *La Revue photographique des hôpitaux de Paris*, while St-Louis saw the opening of 'a magnificent photographic studio which will be a focal point for the most rare and interesting cases pathology can offer'. In medicine, far from the scene of battle, it served to document operations and war wounds: during the American Civil War, in the work of William Bell and Dr Bontecou in Washington, D. C., or, in the war of 1870, the plastic surgery operations carried out by Professor Delalain.

Psychiatrists, however, were perhaps those who resorted to photography most regularly during this period. Attempting to establish the external symptoms of madness, Dr Hugh Diamond, a doctor and member of the Photographic Society, used photography at the Surrey County Asylum from 1850. His images served to illustrate the *Physiognomy of Insanity of J. Connolly* in 1858. Experiments using photography were also carried out at the Bethlem Royal Hospital in Beckenham, again in England, while in Italy, the San Clemente hospital in Venice systematically photographed its patients. Following Diamond's example, Dr Bourneville published in Paris in 1876 *L'Iconographie photographique de la Salpêtrière*, the first volume of an enterprise that continued for several years under the leadership of Charcot, focusing on hysteria in women.

The Englishman Hugh Diamond was one of the first psychiatrists to employ photography in his daily work, keeping portraits (c. 1853; left) of his patients at the Surrey County Asylum for the purposes of typology and from a physiognomical perspective. In his work *Mécanisme de la physionomie*, illustrated with photographs (1856–7;

above), the Frenchman Duchenne de Boulogne, another doctor fascinated by physiognomy, drew up a nomenclature of the face muscles and the sentiments they expressed – a sort of new treatise on the emotions intended for artists as well as scientists.

Ethnologists were not to be outdone, as for example in the Harvard Museum of Natural History or Harvard Museum of Comparative Zoology. It was not long before the first collections of photographed ethnic types were formed, the new technique replacing the taking of casts from nature, both cumbersome and difficult to execute. In addition to these photographic atlases collected during voyages of exploration and colonial expeditions, there were other collections assembled by professional photographers, such as John Thomson's remarkable *Illustrations of China and its People* (1873).

The natural sciences with microphotography and astronomy with macrophotography were also areas that drew advantage from photography, without always achieving the expected results. Apart from the undeniable success of the photographs taken during the total eclipse of 1860, the use of the technique frequently proved disappointing for astronomers: during Venus' passage across the sun in 1874, thousands of images produced by dozens of expeditions all over the world proved to be unusable, not carrying the information it was hoped they would.

The use of the wet collodion process meant that the photographer needed to take on his travels a lot of equipment: a laboratory van, a simple tent (below) or makeshift shelter. In 1865, while covering an archaeological campaign in Egypt, the English-

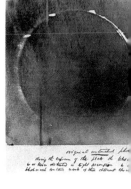

man Piazzi Smyth used the chamber of Pharoah It to develop his prints.

## Still an inconvenient medium

The increasingly frequent recourse to photography soon meant that the issue of teaching it could no longer be ignored, particularly in the realms of architecture and science. Germany was the pioneer in this respect: Kröne opened his own school in Dresden then, from 1870, began to teach in the technical college in the city. In Berlin in 1863, the chemist and physicist Hermann Vogel established a photographic laboratory in the

D uring the total eclipse of the sun in 1860, photography supplied proof for the first time of a phenomenon that all the instruments of observation adopted until then had proved incapable of explaining. On the series showing the various phases of the

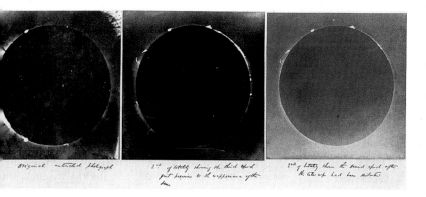

original untouched photograph    2nd of totality showing the third spark just previous to the coappearance of the  ...    2nd of totality show the second spark after the latter one had been distorted

Berliner Gewerbeschule (trade or vocational school). By the end of the 1850s, the technique was already taught in various institutions in London, including the Royal Polytechnic Institution and the London School of Photography. France lagged slightly behind in this field, although, from 1857, teaching began at the Ecole des Ponts et Chaussées (school of civil engineering). This rapid expansion was accompanied by the appearance of specialist magazines and instruction manuals.

The craze for photography should not, however, conceal the medium's still numerous limitations: the extreme sensitivity of the plates, the lack of colour, the unwieldy nature of the apparatus used remained, even by 1870, major obstacles, excluding certain subject matter and holding back the results, especially in the field of science. While the majority of photographers

eclipse taken by two astronomers and photographers, the Englishman Warren De La Rue and the Jesuit priest Secchi, the protuberances emanating from the sun are clearly visible (above). Until then many people had doubted their existence. The two men concluded that 'the protuberances are not mere semblances produced by optical illusion; they are true phenomena'.

seemed to accept this state of affairs, others had been attempting to find a solution since the 1850s.

Although the period saw the birth of true miracles (such as the first successful aerial photographs, taken from a balloon, in Paris [Nadar] and Boston [Black] between 1858 and 1860), the most acute problem remained the awkward nature of taking the photograph itself. The process depended much on the complexity of the operation as on the cumbersome nature of the material: two dozen porters, bearing 250 kilos (550 pounds) of baggage accompanied the Bisson brothers on their 'photographic' ascent of Mont Blanc in 1861.... Even to produce a negative, no fewer than ten operations, requiring considerable knowledge of chemistry and equipment, were necessary: cleaning of the glass negative, preparation and application of the collodion, immersion in the sensitizing solution, exposure in the camera, development and then fixing of the negative image, finally varnishing of the glass to protect the film of collodion, which was rather unstable. The printing process was equally complicated: preparation of the sensitized paper, printing more often than not with the help of a printing frame, directly in daylight, toning to make the print stable and enhance the nuances, fixing and then application of a silk finish, giving a shiny look.

Adding to their complexity, these operations had to be undertaken with some

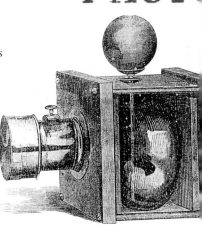

PHOTO

In the early 1860s, tired of working in the studio, Nadar took his darkroom outside, seeking to explore the camera's possibilities: scenes taken in the sewers and the catacombs and then from a balloon guaranteed him publicity (cartoon; top).

form of continuity: the use of so-called 'wet' collodion meant that the negative had to be sensitized, exposed and developed all in one go, forcing the photographer to have a laboratory to hand. Photography outside the studio was therefore particularly difficult. To remedy this situation, a variant on the collodion process was created in 1855, the so-called 'dry' collodion process: it had the advantage of being able to be prepared a long time in advance, the plates being able to be kept for weeks, making it possible to carry out certain steps in the preparation of the negative well before the photo session. The process was not widely used, because it was not very sensitive and called for lengthy exposure times.

Before Ducos du Hauron (image below), it would seem that other inventors had created their own processes: in the United States, Pastor Hill had produced daguerreotypes in colour, while in France Niépce de Saint-Victor had made some attempts on glass, of which, unfortunately, no images remain. Complex and never marketed, Ducos du

RAPHIE DE POCHE

## Towards colour photography

Colour was a second challenge to be tackled: although photographs were rarely 'black and white' in the 19th century, and although there were numerous variations – from black and white to blue and white via brown and white – they were all strictly within the realms of the

Hauron's method was not greeted in the same way by everyone. A certain amount of criticism was provoked by the 'fanciful tones' of his images.

In 1865, the desire to simplify photographic technique led to a reduction in the number of processes, making the apparatus easier to handle. Thus, under the name of 'pocket photography', the camera invented by Dubroni appeared on the market (opposite and above): small and sold with its own laboratory, it seemed the archetype of 'practical photography'. Twenty years ahead of its time, it anticipated the revolution in the miniaturization of cameras of the 1880s.

two-colour process. The lack of any possibility of rendering the different colours of the spectrum was considered an obstacle as far as realism was concerned. Despite its success and the fact that it was universally practised, colouring the print or plate never proved to be more than a stopgap, although subtle, costly and not to everyone's taste.

From the end of the 1840s, various pioneers had studied the problem of reproducing colour in experiments that were often limited and that had no follow-up. It was not until the 1860s that any viable techniques began to evolve. In 1862, Louis Ducos du Hauron embarked upon the construction of a camera for photography in colour; six years later, he patented his process, based on the superimposition of three distinct images, obtained with different filters and coloured papers. Almost at the same time, the poet Charles Cros, who had not heard of Ducos du Hauron's experiments, put forward a similar proposal: based on his so-called 'additive' theory, the image was formed by the superimposition of three negatives, blue, orange and green. These methods did not have any kind of commercial application but served as a basis for 'autochrome', the first colour process to be available commercially, which was developed by the Lumière brothers in the early 20th century.

### Towards the snapshot

Although most of the photographers of the period adapted to the degree of sensitivity of the wet collodion process without difficulty, the latter nevertheless constituted a handicap in

'I should be very glad to possess a lens that did not need focusing. I should carry it [the camera] in my pocket, and with a dry collodion process I could catch positions and expressions in a crowd far better than with my own eyes.... The expression that is unpremeditated and unconscious [of the photographer's presence] is best.'
Oscar Rejlander, 1880

certain fields, such as photography in the dark: the use of artificial light (electricity, magnesium-based inflammable powders) by Nadar in the sewers and catacombs or by Piazzi Smyth inside the Great Pyramid during the 1860s was more a *tour de force* than an indication of current practice.

In the 1870s, in the field of science, where these limitations were more harshly felt, several experiments were conducted to improve sensitivity and reduce exposure times. From 1872, the American Eadweard Muybridge produced studies on the gallop of horses and succeeded, in 1878, in fixing the various phases on wet collodion, revealing through photography a phenomenon that the human eye had not been able to capture. Photography then became, in the words of the French astronomer Janssen, the 'true retina of the scholar'. For several years, the latter had also been carrying out experiments in this area: in 1874, he created a photographic revolver which, at the rate of an image per second, was supposed to enable the various phases in the passage of the planet Venus across the sun to be fixed…on a daguerreotype plate.

The real revolution in exposure times came from a process mentioned in 1871 by the Englishman Richard Leach Maddox: the gelatin silver print. A 'dry' process, it was used rarely at first as it was less sensitive than the wet collodion method. It was only after several years of research and improvements, due in particular to the Belgian Van Monckhoven, that its sensitivity increased considerably, to the point of achieving instantaneity: reconciling ease of use and speed; the silver bromide soon became established after 1879, launching photography into a new era, that of the snapshot.

In 1878, Muybridge's studies of the galloping horse (above) revealed, to general surprise, that at a particular moment in its gallop the animal no longer touched the ground: a totally 'implausible' view, according to a journalist at the time, and one never noticed by the naked eye. Widely circulated via conferences and articles in the popular scientific press, these images were not only admired by scholars, who stressed the amazing photographic feat, but also by artists. Fewer commented on the fact that the series was blurred, due to the use of collodion, preventing real instantaneity.

Known for his carefully composed genre scenes, Rejlander was also renowned for his ability to capture faces and gestures, taken as if from real life (*The Juggler* of 1859; opposite), although often obtained through the use of special effects.

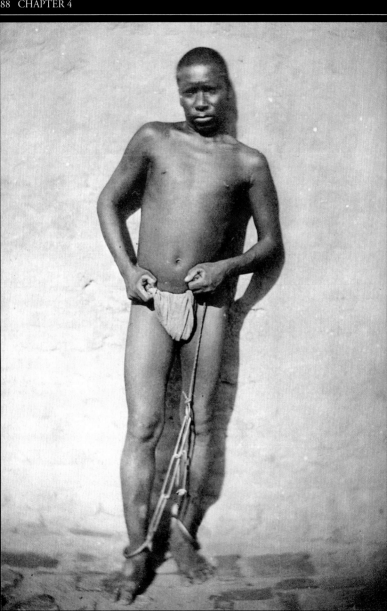

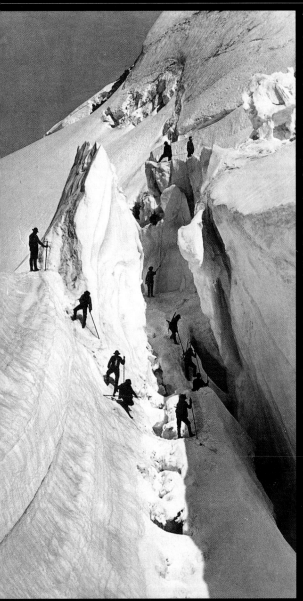

The explorer equipped himself with a camera and the photographer acted as an explorer: in addition to notes, drawings and casts taken from life, the scholar Robert Schlagintweit brought back from his expedition to the Indian continent around 1856 an astonishing number of ethnological photographic studies (opposite); during the same period, the Bisson brothers, established studio photographers, scaled Mont Blanc on several occasions, taking an impressive number of images (1860; left).

Overleaf: photography accompanied the transformation of the great western European cities: Charles Marville covered the works of Haussmann for the Paris city council, immortalizing the quarters destined to disappear or documenting the new street furniture (c. 1870; left). This series served as a catalogue of examples. In 1868, the architectural photographer Thomas Annan carried out a campaign on the working-class areas of Glasgow (right) at the instigation of the city council, which wanted to redevelop them. The series paved the way for the social surveys of the 1890s.

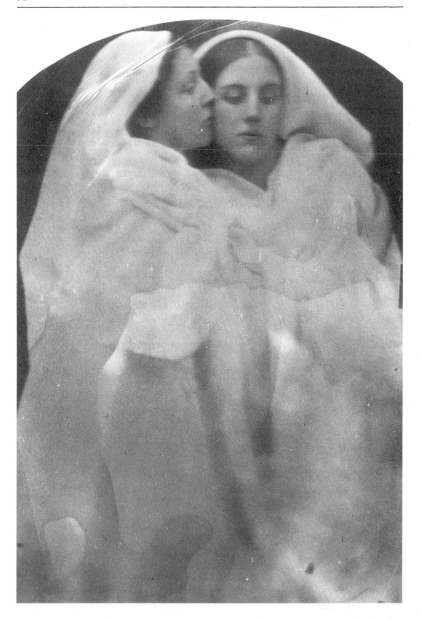

'As for myself, I express the desire that photography, instead of falling into the realm of industry and commerce, should come into that of art. That is its only true place, and it is along this path that I will always strive to ensure it progresses.' These words were spoken at the beginning of the 1850s by Gustave Le Gray, undoubtedly the most ardent champion of photography as an artistic practice.

## CHAPTER 5

## THE REALM OF ART

Two great figures in English art photography: Julia Margaret Cameron was celebrated for her inspired portraits, true 'incarnations of a prayer' (opposite); Oscar Rejlander built his reputation on highly pictorial images, such as this allegory (c. 1856; left), *Youthful Photography Supplying Painting with an Additional Brush*.

The battle appeared still far from won. Although, right from the moment it appeared, some artists had displayed an interest in the daguerreotype process (Rossetti, Ingres, Ruskin), few voices were raised to defend it as an artistic medium: much sought-after for its precision and its sense of detail, the Daguerrean image was immediately placed alongside the mechanical methods of reproduction, devoid of the life and soul that constitute true works of art.

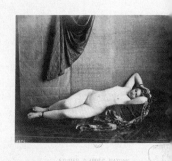

In Paris, the main exhibitions of daguerreotypes during the 1840s took place during the traditional presentations of the 'products of industry'. Although it remained an object of interest, the daguerreotype was only very rarely considered as a creation from the realm of the artist and of imitation: too many mechanics and too little idealism. The very characteristics that made it a tool appreciated by scientists discredited it in the eyes of artists.

The transition from plate to paper, however, brought about a fundamental change. Since the beginning of the 1840s, the processes of Bayard and Fox Talbot had won approval in artistic circles. While the French Academy of Sciences was immediately enthusiastic about Daguerre's process, the Academy of Fine Arts stressed the 'proximity to the drawings of the old masters' of the images of a Bayard, and the historical painter Ary Scheffer highlighted the interest of Hill's prints. This attention is easily explained: during this period, aesthetically speaking, the photograph on paper was quite close in appearance to the artistic methods known and practised at the time – engraving, watercolour, pen and ink drawing. In 1839, Bayard himself had exhibited his photographs amongst paintings in Paris, while at the Academy of Fine Arts in Munich von Kobell and von Steinheil had done the same.

Invented in Arras by two photographers (Grandguillaume and Cuvelier) and a painter (Dutilleux), practised by Corot (above) and the Barbizon school, the technique of the glass negative, a cross between a print and a photograph, illustrates the closeness between painting and photography in the 1850s.

## A favourable milieu: photographic societies

It was really from the beginning of the 1850s that a number of people began to speak out, clearly voicing the possibility of an artistic purpose for photography, entirely freed from its documentary role. At the forefront of this battle were some of the great English and French photographers on paper, often painters by training: as well as Gustave Le Gray, Charles Nègre, Roger Fenton, Henri Le Secq, who had all passed through the studio of the painter Paul Delaroche, Charles Marville, formerly an engraver, and William Newton, a miniature painter....

A painter by training and a well-known lithographer, Vallou de Villeneuve was one of the most talented photographers of the nude in the early 1850s. His photographic nudes (opposite top), female nudes and studies of drapery, skilfully composed and stylised and sold under the generic title of 'studies from nature', were used by artists, such as Courbet, for example in his celebrated *Bathers*.

A lthough he never considered it as an art, Ingres used photography for documentary purposes: as an *aide-mémoire* for certain paintings, or as an instrument for reproduction. He soon had daguerreotypes made of some of his canvases (1852; left), their meticulous precision being particularly suited to his own style. The celebrated portrait of Madame Moitessier can be glimpsed behind the painting on the easel.

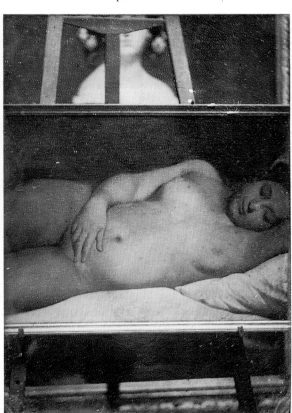

These men all formed groups within photographic societies: the Société héliographique, established in France in 1851 and subsequently transformed in 1854 into the Société française de photographie – still active today; in England, the Calotype Society – described by its founders in the following terms: 'a society composed of a dozen gentlemen amateurs associated together for the purpose of pursuing their experiments in this *art-science*' – was succeeded by the Photographic Exchange Club in 1850 and the London Photographic Society in 1853.

Aimed above all at facilitating the exchange of information between individuals from different backgrounds, but passionate about the new technique, these societies were founded on the model of learned societies. Professional photographers were a distinct minority: at the end of the 1850s, the Société française de photographie numbered barely more than 30 professionals out of a total of 130 members. The majority of members were amateur photographers, mostly from the more affluent classes: men of letters and writers, scientists, well-known artists, inquisitive men of leisure or from the upper-middle class, provincial gentry or aristocrats....

The interest shown in England by Queen Victoria and Prince Albert and in France by Napoleon III undoubtedly contributed in spreading enthusiasm for the new technique amongst the ruling classes. From the 1840s in Great Britain photography was one of the pastimes permitted for fashionable women: a tradition of great Victorian aristocrats with a passion for photography was built on such names as Lady Sommers, Lady Augusta Mostyn, Lady Eastlake, Lady Nevill, Lady Berkeley, Lady Matheson and Lady Hawarden.

In 1849, in accordance with a trend established by painters more than two decades earlier, Le Gray set off to photograph the forest of Fontainebleau (below). A year later, he presented a number of these views on paper at the Salon: taking them for prints, the jury initially agreed that they should be displayed, before realizing its mistake and rejecting them.

Roger Fenton shared with his friend Le Gray an elevated concept of photography (opposite). The variety of subjects Fenton tackled during ten years of activity, with equal rigour, is remarkable: architecture, landscapes, reproductions of works of art for the British Museum, reportage of the war in the Crimea.

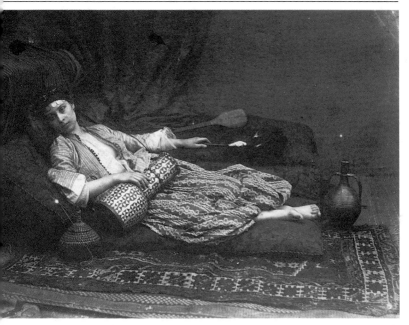

Defending a non-commercial motive, these societies ensured that links between photographic and artistic circles were strengthened: the first president of the London Photographic Society was none other than Sir Charles Eastlake, the history painter and director of the National Gallery in London. One of the founder members of the Société héliographique was the French Romantic painter Eugène Delacroix, who was fascinated by the new technique. 'Let a man of genius use the daguerreotype as it should be used, and it will rise to heights that none of us can imagine,' he wrote in 1853. In the same year, together with Eugène Durieu, minister for religion, amateur photographer and first president of the Société héliographique, he set up academies of photography. Although the example of such close collaboration was rare, painters and photographers frequented the same locations, sometimes working together on the same subject matter, notably at Fontainebleau.

Fenton probably brought the taste for eastern subject matter back from his travels in the Ottoman Empire, completely re-creating scenes in his London studio. Through his extraordinary sense of composition Fenton transforms this odalisque (1858; above), in the tradition of Ingres or Delacroix, into a fascinating incarnation of the East, devoid of the insipid and fake picturesqueness of certain images of the period.

## Exhibitions and critical debate

On the initiative of these societies, the first exhibitions specifically devoted to photography were rapidly organized: in 1852 in London, in the premises of the Society of Arts, and three years later in Paris, in those of the Société française de photographie. Although all aspects of the technique were represented, going well beyond the rigid field of the fine arts, these events were a vital step on the path to recognition of the medium as an artistic practice.

Accounts of these exhibitions and the societies' meetings were published, in their own bulletins as well as in the photographic magazines of the time, such as the *Photographic Journal*, founded in England in 1850, and *La Lumière*, created in France in 1851, encouraging the emergence of a real critical debate.

The vocabulary as well as the arguments tackled were largely derived from pictorial criticism, and explicit references to painting were numerous: thus the first argued defence of photography as an artistic practice that appeared in *La Lumière* in 1851, from the hand of the writer and critic Francis Wey, was full of the ideas of the Romantic school and of the 'theory of sacrifices' (a taste for the picturesque and emphasis on effect rather than precision) dear to a number of critics of the Salon in the 1840s.

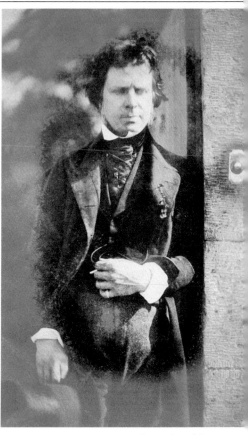

A member of the Royal Scottish Academy, David Octavius Hill (above) was a well-known painter who was highly influential in Edinburgh society at the time he became interested in photography. He was the first painter to leave an important photographic oeuvre, which eclipsed his painting.

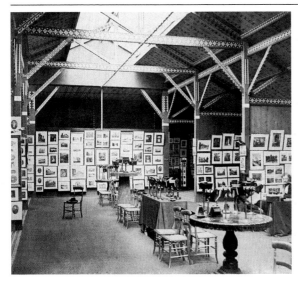

In 1858, a joint exhibition was organized for the first time by the London Photographic Society and the Société française de photographie under the patronage of Queen Victoria and the Prince Consort. Consisting of over 700 images, the show (left) was held in the South Kensington Museum (the present-day Victoria and Albert Museum) which, on the initiative of its director, Henry Cole, had been assembling a collection of photographs for several years. For the English section, the works selected included those of the first generation active in the 1840s (Llewelyn) as well as the second (Rejlander, Carroll, Bedford, Fenton and Howlett). For the French, Le Gray, Nègre and Baldus were shown. The exhibited prints were also for sale. The exhibition, by far the largest ever staged in this field, was well received by the critics.

According to Wey, 'truth in art does not lie in a ruthless and unintelligent copy of nature, but in a spiritual interpretation'. He therefore insisted on the need for the photographer-artist no longer merely to reproduce nature but actually to interpret the subject matter, resorting at times to the 'sacrifice of certain details', which only the use of the calotype allowed. It was only at this price that photography could aspire otherwise to ascend to the rank of art or at least 'to represent a link between the daguerreotype and true art'. An admission that was entirely relative, as can be seen.

In England in 1853, Sir William Newton shocked the Photographic Society by expressing similar views – praising the use of blurred and evocative focusing, as opposed to the belief in any kind of technical savoir-faire.

In 1857, however, Lady Elizabeth Eastlake, the wife of Sir Charles Eastlake, formulated the most succinct theory of the time, contrasting the magnificent calotypes 'in the style of Rembrandt' created in the 1840s by her friend David Octavius Hill with the frigidity of the images produced on glass by her contemporaries.

Undoubtedly the use of paper allowed the photographer a freedom that the use of the daguerreotype did not and paved the way for all kinds of new experiments. Some of the photographs produced in France at the beginning of the 1850s were most certainly affected by the 'theory of sacrifices' and by the omnipresence of painting: Charles Nègre's 'picturesque' genre scenes, the landscapes and still-lifes of Henri Le Secq, Humbert de Molard or Gustave Le Gray.… Although these aspirations to art were born with the advent of the calotype, they gradually became detached from it.

The artistic dimension was not therefore simply limited to one technique (the calotype) any more than to one style (amateur photography). In the 1850s, the majority of photographers concerned about art, whether amateurs or professionals, used both the paper negative and collodion methods, appreciating their transparency and sharpness, and switched from one to the other with no apparent change in style. The most eminent of these, Gustave Le Gray, a well-known professional, practised with equal flair the calotype, the waxed paper process (his own invention), collodion on glass, whether for images taken on his own initiative or as the result of a commission.

From 1855, Nadar joined the ranks of those fighting to have photography recognized, considering, like the majority of his colleagues, that it should be admitted by the Salon. On several occasions he raised the question again – in drawing form – on the pages of *Le Journal amusant*. Opposite, from left to right: 'Photography asking for just a little bit of room in the fine arts exhibition'; 'The ingratitude of painting, who refuses to give the tiniest bit of room in its exhibition to photography, to which it owes a lot'; and 'Painting finally offering a tiny bit of room to photography in the exhibition of fine arts!'

The technique of the photomontage, which appeared around 1850, consisted of producing one single image through the combination of several collodion negatives, was used frequently by Le Gray for his *Seascapes* taken between 1856 and 1859, and in addition allowed him to gain perfect control over the final composition and to 'reconstruct' reality according to his own requirements.

## The 1860s – a turning point

In 1859, after a decade of abortive attempts, the Société française de photographie was at last granted permission to hold its exhibitions at the same time as the extremely popular annual Salon of paintings. This event finally seemed to mark the consecration of the medium, but the technique remained on the threshold of the Salon: the images were displayed in a separate space, albeit an adjacent one. This ambiguous arrangement finally summed up the position that had been granted to photography: neither fully admitted, nor rejected, it remained in the 'no man's land' that defies definition.

Between 1856 and 1859, Le Gray produced several dozen *Seascapes* which were exhibited and sold commercially, earning him both public and critical acclaim. In many of them, Le Gray combined two negatives, one for the sky, the other for the sea (each requiring different exposure times) – the only technique at the time to provide a rendition of the sky as powerful as that of the waves. In these images (left and far left), the same negative, centred differently, has been used for the sky. A photographic tour-de-force, these seascapes looked like real, often monumental, compositions. 'It is right to say that in composition and effect, everything is favourably joined to provide the appearance of a painting,' declared the bulletin of the Société française de photographie.

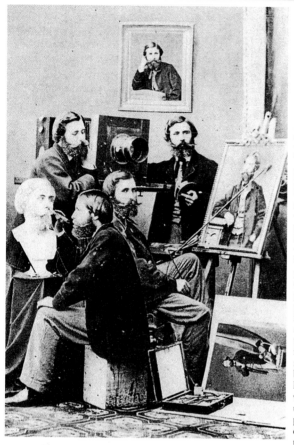

Multiple portraits were highly prized during the period. In the example illustrated here (c. 1860; left), the studio portraitist De Torbechet, has focused on the theme of photographer as artist, creating this multiple self-portrait, obtained through the use of photomontage. The position of photography in the ranks of the fine arts, between painting and sculpture, is highlighted with humour and a touch of self-importance.

❛For a long time, photography was content to offer to passers-by those black things made in their image. They were no more disturbing than the silhouette cut-outs found at the fair; but recently, expanding its business, photography has declared its products works of art. It has given us travels, copies of paintings, even original compositions, and all this has begun to sneak surreptitiously into displays, between the bronzes and the paintings.❜

Marcelin,
*Le Journal amusant*,
1856

Reaction was mixed, when it was not openly hostile. The art critic Philippe Burty, author of an article in praise of photography at the Salon of 1859, pronounced, however, that photography 'is not art, since art is a constant idealization of Nature'; he therefore limits its role in the future to that of a favourable substitute for 'cheap lithographs', adding his own to the chorus of voices who continued to regard it as nothing but 'the humble servant of the Arts'. As for Baudelaire, in his *Salon de 1859*, he penned one of the

most violent diatribes against the technique: 'This new industry…can only contribute to ruining what might remain divine in the French spirit.' His accusation echoes a great number of critics from the period, condemning at the same time both photography and painters linked with the realist movement.

The movement that had accompanied the creation of the photographic societies ran out of steam at the end of the 1850s, while the industry gained ground. The great generation of pioneers from the 1850s gradually abandoned the stage, both in England and France: Le Gray ruined, Fenton worn out, Nadar obliterated, Nègre and Le Secq retired.… Many of the most ardent champions in the decade between 1840 and 1850, such as Delacroix and Ruskin, had by then turned away. From then on it was the commercial photographers who assumed the title of artist, while often using stereotyped formulas, devoid of any talent: Alophe, successor to Le Gray, published *L'Art du photographe* in 1860, Disdéri *L'Art de la photographie* two years later.… Never had the term art been so widely used.

In 1862, they could all brandish a judgment passed by the Seine court in which it was announced for the first time that 'photographic drawings need not necessarily and in all cases be considered devoid of any artistic character, nor categorized according to the number of purely material works'. Despite its restraint, this decision provoked a general outcry in artistic circles, revealing the fragility of photography's position: thirty or so artists, painters and engravers – amongst them Ingres, Hippolyte Flandrin, Puvis de Chavannes and Constant Troyon – protested in a petition 'against any comparison which might be made likening photography to art':

In 1856, the draughtsman Marcelin published an article in *Le Journal amusant*, solemnly entitled 'Down with Photography!' He denounced in it the artistic pretensions of the new medium – this 'abominable invention' personified in the guise of an old slut (below), a working-class woman with middle-class aspirations. Amongst photographers, only his friend Nadar was explicitly spared from this wholesale massacre.

photography, they considered, 'amounts to a series of entirely manual processes' and 'the resulting prints cannot under any circumstances be compared to works that are the fruit of intelligence and of the study of art'. Subsequently, several contradictory judgments only added to the confusion.

## An English peculiarity

It was undoubtedly in England, from the mid-1850s, that the most overtly pictorial photographic trend developed. A handful of photographers – the decorator and designer William Lake Price, the Swedish painter Oscar Gustav Rejlander, Henry Peach Robinson – all formed part of a trend known as 'High Art Photography', and attempted to emulate the most noble genres of painting. Between 1854 and about 1860, there was an increase in the number of photographs with religious, historical or allegorical subject matter, created with the aid of actors in costume and of 'combination printing', a photomontage of various negatives, aimed at reconstructing an 'ideal' image.

Nourished on the Italian art of the Renaissance and on the art of their contemporaries the Pre-Raphaelites, inspired by the practice of tableaux-vivants, these photographers shared a taste for narration and fiction,

Rejlander's *Two Ways of Life* (1857; above) was an allegory whose composition was inspired by Raphael's *School of Athens*. Having reached manhood, two brothers leave their family home to head for the city: the first adopts a life of labour, while the second is attracted by the sirens of idleness and lust. As soon as it was displayed, the work started a double-sided debate: critics pondered whether it was appropriate to use photography to treat an allegorical subject; others protested against the presence of nude figures. Indeed, the following year in Edinburgh the image was exhibited with the left-hand side concealed by a curtain.

and common sources of literary inspiration: Shakespeare, Walter Scott and, above all, the great Victorian poet Alfred, Lord Tennyson.

They benefited, moreover, from the benevolent support of the Crown: in 1857, Queen Victoria acquired for her husband, Prince Albert, Rejlander's *Two Ways of Life*, a photographic allegory and veritable image-manifesto of this movement, which was displayed at the time at the 'Art Treasures' exhibition in Manchester.

The trend for High Art Photography pushed dependence on the pictorial model still further, sometimes to the point of unintentional pastiche. In his work *Pictorial Effect in Photography*, published late in 1869, Robinson (1830–1901) goes back over the rules of composition, harmony and equilibrium that must prevail in order to achieve the 'pictorial effect'

Among the exponents of High Art Photography, Henry Peach Robinson was the most skilled at photomontage (preparatory study of c. 1858; below): the photographer prepared his composition by first doing a drawing, then dividing the image into as many separate shots as necessary. Sometimes accused of 'patchwork' by his detractors, he declared, 'I maintain that I can get nearer the truth for certain subjects with several negatives than with one.'

THE LADY OF S

Both the Pre-Raphaelite movement and High Art Photography drew their inspiration largely from the Arthurian legends revived by Tennyson: Robinson's *The Lady of Shalott* (1858; left), whose composition was greatly inspired Sir John Everett Millais' painting *Ophelia* (1851–2) was created by combining two negatives, one for the model reclining in the boat, the other for the surrounding landscape. By means of this trick, perfectly calm water could be obtained, on which the boat appears literally to float. From 1874 to 1875, Julia Margaret Cameron, given the task of illustrating some poems by her friend Tennyson, made actors and relatives in costume pose for her camera. In this *Death of King Arthur* (1874–5; above), she scratched directly on to the negative plate to represent the moon. The waters of the lake were evoked by sheets placed on the studio floor.

appropriate to all art photography. The principles set out were largely inspired by the Royal Academy of Art's teaching of painting. In the book Robinson underlines the importance of resorting to the photomontage, even if only to restructure, modify and idealize raw nature, stating that the exact representation of disordered nature was the truth; the same representation ordered with discernment was truth and beauty; the former was not art, the latter was.

M ore than just a mere pastime, photography was, for Lewis Carroll, a real passion to which he devoted a considerable amount of time and

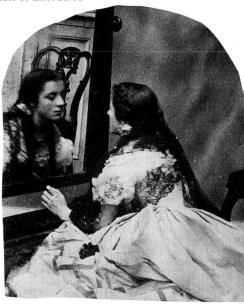

Although this trend gradually died out at the beginning of the 1860s, numerous echoes can be found right up to the end of the 1870s, in stereoscopic photography, which was particularly fond of these narrative and composed scenes, as well as in the work of several English amateur photographers: Lady Clementina Hawarden, the writer Lewis Carroll and, above all, Julia Margaret Cameron. Their images testify to an audacity and freedom of composition that would be hard to find in the commercial production of the period: Lewis Carroll's carefully composed portraits of children, tirelessly repeated between 1855 and 1880, Lady Hawarden's studies and tableaux-vivants, using her three daughters as the sole models – mostly photographed inside their London home – must surely figure as the most original images of the time.

Julia Margaret Cameron (1815–79) came to photography late, in the mid-1860s, when she was over fifty years old. Both technically – the intentional blurring of her images, the extremely high exposure times imposed on her models – and formally – scenes in costume or illustrations from Shakespeare, or Tennyson

several brief articles. With talent and perseverance, he produced portraits of young children, particularly young girls, for over twenty-five years. Any opportunity for discovering new models was valid, as, for example, during a visit to his favourite actress, Ellen Terry, when he photographed all her brothers and sisters (1865; opposite).

– her photography went against the tide. Her limited oeuvre, archaic and magnificent, in which each image is 'a combination of the real and the ideal' extended, late into the century, right up to her death in 1879, the dramatic and already distant breath of the founders of photography.

The vast majority of portraits by Lady Hawarden (c. 1860; opposite) were variations on the theme of the double, halfway between studies from nature and dramatic scenes.

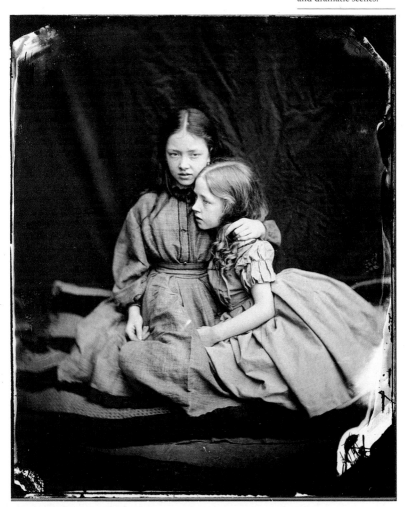

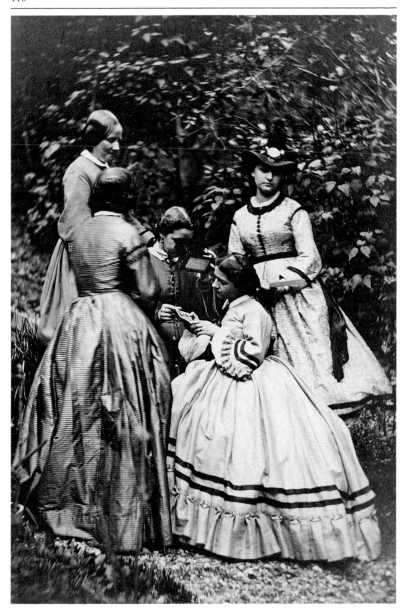

With the advent of the photograph on paper, the photographic image multiplied, and began to arouse interest in the worlds of publishing and the press: from the 1850s, books and periodicals on photography increased. At the same time the development of methods of transport, the expansion of tourism and international commerce led to new activities and the creation of methods for spreading the image.

CHAPTER 6

## THE SPREAD OF THE PHOTOGRAPHIC IMAGE, 1840–80

New techniques, new supports: the mid-1850s saw the advent of the photograph in relief, the so-called stereoscopic image, which rapidly became a popular hobby amongst the middle classes (*An Outdoor Session with the Stereoscope*, c. 1865; opposite). Periodicals regularly illustrated with photographs appeared, one of the earliest examples being *The Far East* (left), published in Yokohama. Between 1870 and 1878, each issue of this monthly journal devoted to the Far East contained from six to eight prints.

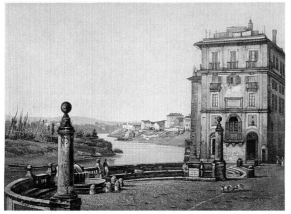

The main work
produced from
daguerreotype images,
*Excursions daguerriennes*,
appeared between 1840
and 1844. A comparison
between the few
surviving plates and
the engravings (left
and below, Porto Ripetta
in Rome) seems to show

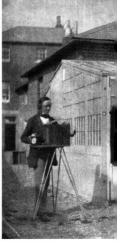

that the draughtsmen's
interpretation of the
views was often
subjective.

## A multiple image

While the unique nature of the Daguerrean plate was
not a major obstacle as far as portraiture was concerned,
it meant that the process was unsuitable for many
applications. Methods of engraving directly from the
daguerreotype plate were invented at the beginning
of the 1840s, the most impressive of which was the
one developed by Hippolyte Fizeau. They remained,
however, complex to use and their results were uneven.
In order to multiply the Daguerrean image, it was
necessary to turn to engravers who produced images
'after the daguerreotype', echoes often cold and distant,
devoid of the magic and charm of the originals on which
they were based.

In 1840, Fox Talbot saw in the
multiple and reproducible nature of
his process its main advantage over that
of his rival, declaring that every man
would be able to become his own
printer and publisher. Putting his ideas
into practice, he opened the first
photographic printers in Reading in
the autumn of 1843. In the space of
three years, it produced four books
illustrated with photographs.

The first and most important, *The Pencil of Nature*, amounted to a presentation, even a panegyric, of his process. In it, Fox Talbot listed the advantages of the calotype in fields as varied as architectural photography, genre scenes, portraits or the reproduction of works of art. In each copy, the original proofs on salted paper were stuck in by hand, with an explanatory text on the facing page: an incredibly repetitive and tedious task,

Although Fox Talbot's printing works at Reading (1846; below) only employed six or seven people, it was already characterized by a division of tasks similar to those that existed in the great photographic studios. In Fox Talbot's

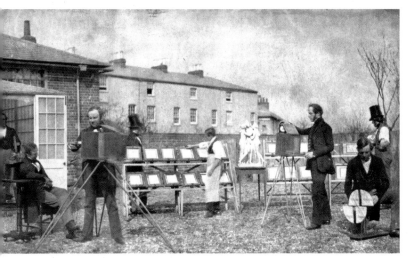

preventing a large print run. The book was published in instalments between 1844 and 1846, but was not a success. In the end, Fox Talbot sold only about one hundred and thirty complete copies.

The three subsequent works, *Sun Pictures in Scotland* (1845), a homage to the Romantic Scotland of Sir Walter Scott, and two books of reproductions of archaeological objects and works of art were no more successful, despite some noteworthy subscribers, including Queen Victoria. This failure can be explained partly by the high cost of the publications and partly by the poor conservation of the prints. In 1847, the establishment was forced to close.

absence, his assistant Henneman took charge of taking the images, delegating the more run-of-the-mill tasks to others. The establishment also carried out both the printing and the distribution of images by other photographers (Calvert Jones, Bridges) as well as providing premises where one could have one's portrait taken, take lessons in photography or acquire photographs.

## Blanquart-Evrard's printing works

The establishment in Reading remained an isolated initiative and its relative failure did not encourage others to pursue that path. It was not really until the improvements introduced to Fox Talbot's process by Blanquart-Evrard at the beginning of the 1850s that photographic printers began to appear. In Paris, several printing houses, such as Fonteny, Lemercier, Gide et Baudry or Didot embarked upon the experiment, sustained and meticulous, of books illustrated by photographs.

Blanquart-Evrard himself, however, was behind the most significant establishment of the period, opened in 1851 at Loos-lès-Lille, on the outskirts of Lille, employing about forty workers. The improvements introduced to Fox Talbot's method, particularly in the area of printing the proofs, allowed for a greater standardization of tasks, a more significant output and consequent reduction in costs. Whereas in Reading it had sometimes taken hours to print a contact proof, in Lille the same task could be achieved through developing in about ten seconds in full sunlight.

In four years, between 1851 and 1855, over twenty photographic albums were published there, portfolios of images on salted paper, on a wide variety of themes (the banks of the Rhine, religious art, studies from nature), representing more

In the decade between 1843 and 1853, the Englishwoman Anna Atkins created a collection of plates on the theme of marine flora of the British Isles, *British Algae*. In order to carry out what would appear to be the first scientific work to be illustrated by photographs, Atkins resorted to the technique of the cyanotype, a printing process invented by Sir John Herschel in 1842 that produced images with bluish tones (below).

Laminaria saccharina.

than 500 negatives: most of the great French and Belgian calotypists supplied the establishment with images. As in the case of Fox Talbot several years earlier, however, the enterprise turned out to be a commercial failure: insufficient demand led to the closure of the establishment in 1855. This failure also marked the end of the calotype in France. It had proved to be incapable of finding a wide enough public beyond a limited circle of amateurs, artists and scientists.

## The emergence of photomechanical processes

Their differences aside, Fox Talbot and Blanquart-Evrard faced the same problems. The first was related to the production costs of works illustrated with original prints, much higher at the time than those of books illustrated with engravings and lithographs, as each image had to be printed, cut and stuck by hand – a method of production that was extremely labour intensive, making the circulation of a book on a large-scale extremely difficult.

The second concerned the unstable nature of the photographic prints. This problem preoccupied the photographic fraternity during the 1850s: the premature fading of prints, often badly printed or stuck with a glue of inferior quality, as in the example of *Sun Pictures in Scotland*, caused much concern, undoubtedly dissuading potential buyers and investors.

In France, the first real book to be illustrated by photographs appeared in 1852, *Égypte, Nubie, Palestine et Syrie* (an illustration from the book; above). Taken by Maxime Du Camp during a journey with Flaubert from 1849 to 1850, the images were printed at Blanquart-Evrard's printing works. The prints were sometimes unfairly criticized for their 'pale, uniformly grey tonality'.

The combination of these problems led to the search for other methods of printing, which were both easier to use in the printing works and more durable, even permanent. The future seemed to lie in photomechanical procedures, which aimed at reproducing photographs with methods inspired by engraving or lithography: the impression was thus no longer natural but actually mechanical. Between 1851 and 1854 in France, Charles Nègre and Edouard Baldus invented their own techniques; in Austria, Paul Pretsch did the same with his photogalvanographic process, which he marketed in England with moderate success.

In 1858, Fox Talbot himself took out a patent for his 'photoetching', a technique that he once again proved incapable of marketing. The majority of these photographers, moreover, participated in the contest started in 1857, on the initiative of the Duc de Luynes, lover of art and photography, under the auspices of the Société française de photographie and supposed to reward the technique supplying the most permanent images, particularly in the field of photomechanical processes.

The prize was eventually awarded, ten years later, to the Frenchman Alphonse Poitevin for his carbon print process. Valued as much for its permanent nature – it was said to be unalterable – as for its aesthetic qualities, particularly the extreme intensity of its blacks, it rapidly became established.

Improved and subsequently patented by the Englishman Joseph Wilson Swan in 1864, this carbon process was used in the years that followed by some of the greatest photographic publishing houses, including those directed by the Haenfstangel in Germany or Braun in France, as well as the Autotype Company in England.

Adolphe Braun soon acquired a reputation for the excellence of his carbon prints: reproductions of works of art from most of the great European museums (the speciality of his publishing house), landscapes and views, but also an impressive series of highly pictorial still-lifes (c. 1867; above). Reputed to be unalterable, often of considerable size, the still-lifes were really carefully planned and sold to be displayed permanently on a wall.

The jury of the Société française de photographie unquestionably were very perceptive: the technique perfected by Poitevin served as the basis for the majority of the photomechanical processes that appeared after 1865. From this date on, the gradual replacement of original prints by photomechanical methods brought about a considerable reduction in the cost of producing works illustrated with photographs and led to higher circulation.

The first and most widely used of these processes was the woodburytype, which appeared in 1865: extremely popular during the 1870s and 1880s – in France, it was marketed by the firm of Goupil under the name of photoglyptic – although complex to use, it was

Charles Nègre, who saw heliographic etching as the 'indispensable complement to photography', invented a high-quality photo-mechanical process (reproduction of *The Silence of Death* from 1858 by the sculptor Préault; above). It was, however, complex and labour-intensive, factors that dissuaded the jury of the Duc de Luynes' competition from awarding him a prize. Even more astonishingly, the jury was unaware of the process invented by Thomas Woodbury, the woodburytype, which was soon a huge success. Producing images in which the contrasts were at times too harsh, the technique nevertheless led to the creation of some very successful images, such as the plates in John Thomson's *Street Life in London* of 1877–8 (*The Crawler*; left), which were reproduced directly from the original negatives.

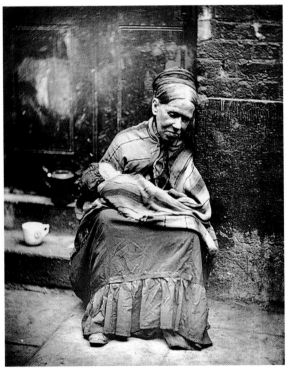

gradually replaced by the collotype, last in the line of great photomechanical processes of the 1860s.

Invented by Albert in 1868, the collotype was largely based on the work of Poitevin. The same techniques served as the basis for the research of the 1870s into photomechanical processes in colour: in Vienna, Albert produced his first collotype in colour around 1874, while Vidal invented the photochrome shortly afterwards, combining chromolithography and the woodburytype methods.

## Photography as illustration in the press

The problems encountered by the publishing world were experienced even more acutely by the press, where the impossibility of printing photographs directly was harshly felt. Although newspapers employed photographers, it was in order to be supplied with models, interpreted by engravers, then inserted under the form of lithographs, or engravings on wood or zinc.... Numerous photographers worked in this very fashion for the press. While the phenomenon had appeared sporadically since the early 1840s, it was in the 1860s that the note 'from a photograph' under the captions of illustrations in the press became increasingly common, testifying to the accuracy of the image reproduced.

This state of affairs continued right up to the 1890s, despite rare attempts, including the process created by Charles Gillot, to insert photographic prints directly into newspapers. It was a delicate and cumbersome experiment for periodicals with large print runs, and rarely culminated in success. As early as June 1846, *The Art Union* had published a calotype by Fox Talbot, printing 7000 copies.

During the 1850s and 1860s, professional magazines devoted to photography (*The Photographic Art Journal, La Lumière, Photographic News, The Photographic Magazine*) occasionally offered one or more prints to their readers. These experiments were, nevertheless, mainly limited and isolated; in the United States, however, *The Photographic and Fine Art Journal* regularly published images.

In 1857, Désiré Charnay obtained from the French Ministry of Education a photographic commission that took him to Mexico; during the winter of 1859 to 1860, he became perhaps the first westerner to photograph the site at Mitla (opposite). Most of these images were subsequently reproduced in *Cités et ruines américaines*, published in Paris in 1863. It was, above all, through the popular press that his images were widely circulated, since many views were copied by engravers: initially in *L'Illustration* (opposite below) in 1861 and 1862, then in *Le Tour du monde* in 1862, and finally in *Le Monde illustré* in 1865.

Engravers working for the press used both wood (opposite) or zinc (zincograph) as a support for their drawings based on photographs. From the end of the 1870s, the use of 'wood film' allowed the photograph to be directly engraved using a burin on to the plate, without the need for an intermediate drawing.

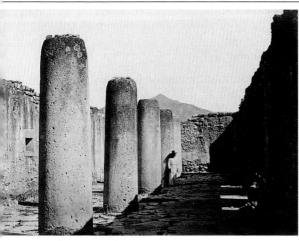

Even though it could not use photography directly, the illustrated press was quick to realize the advantage it could take from it. Hence, in 1855, it was possible to read on the pages of *L'Illustration*: 'As for means of satisfying the public, they have multiplied through the discoveries of science and art responding to the requirements of social activity, that is to say with the admirable assistance of photography, that

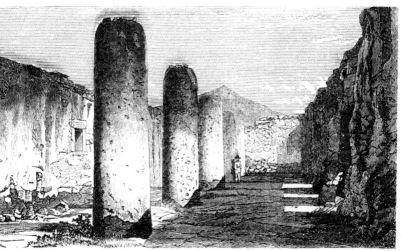

From the 1850s, in the more specialized fields, a number of magazines published photographic prints, valued for their faithfulness to the original model. When reproducing works of art and archaeological treasures, periodicals used them relatively frequently towards the end of the 1850s, in Belgium, the Netherlands,

fast and accurate method of laying before the eyes of every nation anything interesting that is offered and accomplished in the other corners of the globe.'

Germany, Great Britain and France: *La Gazette des Beaux-Arts*, *Archäologische Zeitung*, to name but two examples. From the 1860s, the medical world also made use of the photographic image, notably *La Revue photographique des hôpitaux de Paris*, in France from 1869.

## Tourist attractions

'Well, there you are, just about to set off for Italy again! If by any chance you find any photographs of well-known antiquities or paintings... buy them...bring back anything you can find, works of art or landscapes, people or animals,' the painter Millet wrote to a photographer in 1865.

From the 1850s, photography on paper revived the extensive market of the lithograph, often taking up its subject matter and compositions – views, monuments, landscapes, genre scenes, reproductions of works of art. Helped by the development of methods of transport, tourism expanded in the second half of the century, leading to a demand for photographic views.

The countries on the Grand Tour – Italy, Greece and the Mediterranean region – were the most affected. In Italy during the 1850s there was a notable rise in the number of local photographers whose production was principally aimed at this tourism of the elite: in Rome, with Molins and Altobelli, renowned for their views of ruins brought to life with people and for their nocturnal effects; in Florence, where, in 1852, the Alinari brothers settled, soon becoming the largest publisher of photographs in the pensinsula, particularly for views of monuments and reproductions of works of art, especially the paintings in the Uffizi. It was in Venice,

REVUE PHOTOGRAPHIQUE
DES HOPITAUX

Planche VIII.

TORTICOLIS CONGÉNITAL
N° 5

An initiative undertaken by the St-Louis hospital, which was equipped with a photographic studio at the end of the 1860s, *La Revue photographique des hôpitaux de Paris* appeared monthly between 1869 and 1876. Once the photograph was taken and printed, the image was coloured by hand (above), in the presence of the patient. This tricky procedure was only possible in the case of specialized magazines with limited circulation.

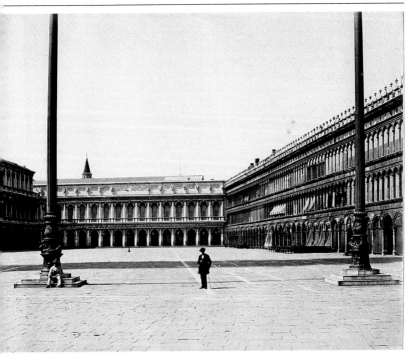

however, that competition was toughest, with studios run by Ponti, Bresolin, Naya, and Perini, among others. In 1870, the windows of over twenty-five photographers could be counted around St Mark's Square.

Local photographers were joined by a large number of foreign photographers who set up in business: in Naples, one of the main studios was run by Sommer, a German from Frankfurt, while Rome was home to the British photographers James Anderson and Robert Macpherson, greatly admired for his extremely large formats of the countryside around Rome.

Greece was not to be outdone, especially Athens, where the 1850s saw the opening of the studios of Margaritis, Konstantinou, Zangaki, Moraites. Most of their work, which was often very similar, was focused on the monuments, sculptures and fragments of the Acropolis. In the Ottoman Empire, in the countries

During the 1840s, while visiting Venice, Ruskin acquired some daguerreotypes of monuments. Thirty years later, a Venetian economist remarked that 'in almost all the villages of the Veneto, one finds photographers. They make considerable profits and also sell much abroad'. The epicentre of this commerce, St Mark's Square (c. 1860; above) was also one of the subjects most frequently represented.

forming part of an extended Grand Tour (including Turkey, Syria, Lebanon, Palestine, Egypt), it was above all after 1860 that the great commercial studios appeared, often at the beginning the work of Europeans who had settled there: the German Rabach, returning from the Crimean War, and the Englishman James

In Constantinople during the 1850s, Robertson, in partnership with his brother-in-law Felice Beato, became the specialist in views brought to life by

Robertson, a former medal engraver to the sultan, opened the first studios in Constantinople.

Some trained local photographers who then took over. By the end of the 1860s, an increasing number of studios were run by locals: the Abdullah brothers, portraitists trained by Raubach and official photographers to the sultans and to dignitaries passing through Constantinople, or Pascal Sebah and P. Bergheim, active in Jerusalem…. Without a doubt,

local characters (c. 1854; above). This vast production, hastily printed on albumen-coated paper and stuck on to cheap quality card, did not age well. However, some images maintain a beautiful sepia tone.

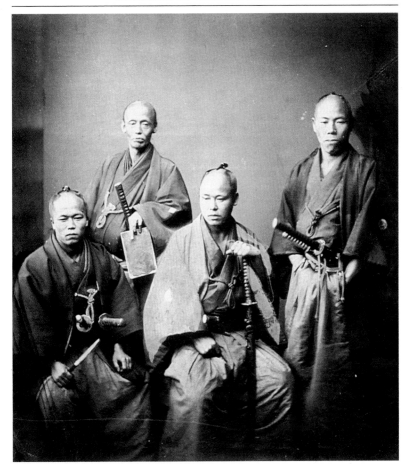

however, the greatest studio in the region during the 1870s was Bonfils, founded in Beirut in 1867 by the Frenchman Félix Bonfils, who travelled the length and breadth of the Ottoman Empire, collecting views of monuments and landscapes, with the help of his wife and son. Four years after it was founded, his business was able to offer an impressive catalogue: 15,000 images and 9000 stereoscopic plates of 'curiosities from the entire East'.

Having travelled throughout the Ottoman Empire and China, Felice Beato was the first western photographer to settle in Japan, where he founded a school renowned for its hand-painted landscapes and genre scenes (top).

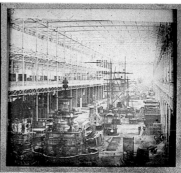

## Stereoscopic views

The stereoscopic photograph, ancestor of the 3-D image, was extremely popular throughout the second half of the 19th century. Invented by an Englishman, Sir Charles Wheatstone, at the end of the 1840s, the process was marketed by a French optician named Duboscq and shown to the public for the first time at the Great Exhibition held at Crystal Palace in 1851. The shot was taken with the aid of a camera with a double lens, resulting in two small images approximately 10 × 10 cm ($3\frac{7}{8}$ × $3\frac{7}{8}$ in.) each, in which the angle of the viewpoint differed very slightly. Viewed with the aid of a special device, the stereoscope, and when combined, these two images restored the illusion of relief and depth.

There was an immediate craze for the stereoscope. As in the case of the *carte de visite*, the reduction in format helped to keep costs down and therefore established rates: the process rapidly became a popular pastime. Relatively cheap, the stereoscopic view soon created a vast market, with numerous photographers and editors specializing in this field: Duboscq and Soleil, Gaudin, Ferrier or Braun in France; Anthony in the United States; Negretti and Zambra or the London Stereoscopic Company in England.... The most popular subject matter consisted of genre scenes posed in the studio, nudes, often licentious in nature, so-called 'instantaneous' scenes, made possible by the reduction

From its first appearance at the Great Exhibition at Crystal Palace in 1851, the stereoscope became a craze. It is said that the optician Duboscq presented a device to Queen Victoria, together with several images, including perhaps this view of the interior of Crystal Palace captured on daguerreotype during the setting up of the Great Exhibition (above). In 1854, the newly-founded London Stereoscopic Company adopted as its slogan 'A Stereoscope in Every Home' and, two years later, over 10,000 views were offered in its catalogue. The stereoscope went through numerous changes in the course of the century and generated a huge market in images and apparatus, as well as in viewers (opposite above) of all kinds.

in format, and above all, topographical views, the main field in which the stereoscope was used, the true ancestor of the postcard, which did not appear until about 1890.

## The great publishing houses

Photographs produced with the tourist market in mind were available from the photographer's studio, various print dealers and bookshops, as well as at stations and in hotels. The distribution of these views was rapidly assured abroad through reciprocal exchange agreements between photographers. Many of the great European publishing houses specializing in

During this period, the length of the exposure time was proportional to the size of the negatives: the small dimensions of the stereoscopic photograph allowed

prints also focused on this market: Gambart, Colnaghi and Agnew in England; Goupil in France.

Likewise, the 1850s witnessed the creation of large publishing houses specializing in the market for photographic prints, topographical views and reproductions of works of art, with copious catalogues: Alinari Editori Fotografi was founded in Florence in 1854, Frith in London in 1856 and Braun in Dornach

images to be obtained almost instantaneously, an impossible achievement in larger formats. The earliest views of Parisian streets (above), showing moving pedestrians and carriages, aroused astonishment and admiration.

in 1859. Initially simple individual enterprises set up by photographers, they transformed themselves into true publishing houses, when they became successful, using and distributing the work of numerous photographers. In the 1860s, Frith offered over 10,000 views, mainly of the East; Braun's catalogue contained 6000 views, particularly of Switzerland and Germany, while Alinari mentioned over 70,000 images in 1880.

The majority of these publishing houses offered their images in a variety of sizes, ranging from the *carte de visite* to much larger formats – 40 × 50 cm (15¾ × 27⅝ in.) – and including, most importantly, the stereoscopic format, the most sought-after for topographical views. They competed with original and large-scale formats: Braun's panoramic format of 27 × 51 cm (10⅝ × 20⅛ in.), 'extragrand' of 54 × 43 cm (21¼ × 16⅞ in.), 'imperial' of 90 × 70 cm (35⅜ × 27⅝ in.). Prints were available in plate form, in albums or in portfolios. As well as topographical views, events, particularly images of catastrophes – fires, earthquakes, wars – were particularly in demand: views of Paris in flames in 1871 and of Chicago in the same year circulated all over the world.

### Towards vital legislation governing copyright

The inflation of images, the internationalization of the exchanges and the growth in competition did not occur without problems. The piracy of prints was common practice, particularly where the reproduction of works of art were concerned, as it was particularly difficult to detect. In 1881 in Venice, Naya was brought before the courts by several photographers who accused him of having stolen their images, while Ponti laid claim to a large number of prints that were not his. The repurchase of catalogues of former publishers by

Founded in Florence in the 1850s, the firm of Alinari soon acquired a reputation in the field of landscape and the reproduction of works of art (catalogue of sculptures in the museums of Naples, c. 1880; above). The firm expanded rapidly: at the beginning of the 1880s, it employed over a hundred people; it is still active today.

Overleaf: one of Le Gray's most famous seascapes, *The Breaking Wave* (1857).

various photographers signing the images with their own names – rather than resorting to the use of technicians who sometimes claimed royalties – made the situation even more complex. Legislation had remained in its infancy: in France, royalties were defended by a law dating back to 1793 that was obsolete. Compulsory after 1852, the registration of copyright for the print, aimed at guaranteeing it was protected, was not always respected. Piracy became punishable with imprisonment. By contrast, prior to 1862, none of this existed in England: following an intensive campaign of lobbying, this year marked the passing of the Copyright Act, which launched a wave of cases. The penalty incurred – a fine of ten pounds – was not much of a deterrent. While the legislation passed in Germany seemed to be the most effective, it must be recognized that in the majority of countries its content was still at an embryonic state, managing only in a very loose manner the prolific spread of the photographic image during the second half of the 19th century.

For, by the end of the 1870s, photography finally appeared to have come of age. Technically reliable, in the hands of professionals, sustained by rapidly expanding methods of circulation, it had, within the space of three decades, conquered the principal fields of human activity.

In just a few years, during the 1880s, this balance was totally upset by the revolution brought about by the snapshot, symbolized by the invention of the Kodak camera: new techniques (simpler and faster), new applications (more user-friendly), a new public (consisting of amateurs) began to see the light of day, bringing about, forty years after the announcements of Arago and Fox Talbot, a 'renaissance' in photography.

In certain circumstances, the police kept a close eye on the commerce of photographs. In France, under the Second Empire, the market in nudes was subject to close observation by the authorities, involving numerous seizures of unlicensed photographs (from 1862; above), judged obscene and banned from being sold.

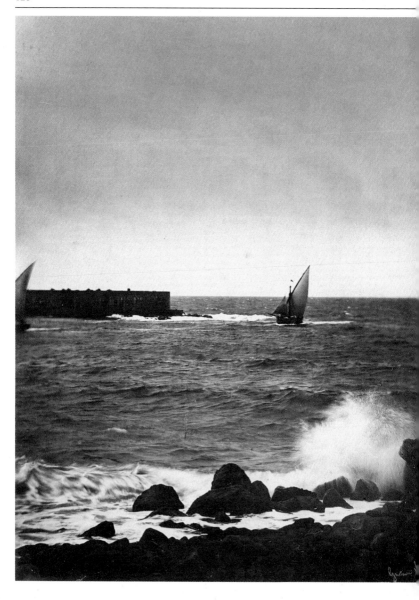

# DOCUMENTS

# The beginnings of photography

*Before the first official communications, by Arago, Daguerre or Fox Talbot, the main source of information regarding the various processes is to be found in the inventors' notebooks and in private correspondence. Reading these letters, a hidden history of the beginnings of photography starts to emerge, founded on mystery and unspoken comments, unverifiable facts, rumour and suspicion.*

### With a ring box and a solar microscope lens

You know from my last letter that I broke the lens of my camera obscura; but I had another which I was hoping to be able to put to good use. It was a false hope: the focus of this glass was shorter than the diameter of the box; so I could not use it. We went into town last Monday; I was only able to find a single lens at Scotti's with a focus longer than the first, and I have had to lengthen the tube holding it, with which the true length of the focus can be determined. We came back here on Wednesday evening: but since then the weather has always been cloudy, preventing me from continuing with my experiments, and I am all the more angry since I am finding them very interesting. We have to go out from time to time, visiting or receiving visits: it's tiring; I would prefer, I swear, to be in a desert. No longer being able to use my camera obscura, when my lens was broken, I made an artificial eye with a ring box belonging to Isidore [Nicéphore's son], which is small, 16 or 18 *lignes* square. Fortunately, I had the lenses from the solar microscope which, as you know, belonged to our grandfather Barrault. One of these little lenses was exactly the right focus, and the image of the objects was clearly and sharply visible on a field measuring thirteen *lignes* in diameter. I placed the apparatus in the room where I work opposite the aviary, with the windows wide open, I carried out the experiment following the process you are familiar with, my dear friend, and I saw on the white paper all of the part of the aviary which can be seen from the window, and a faint image of the windows which were less well lit than the objects outside. One could see the effects of light in the representation of the aviary and right up to the window frame. This is only an attempt which is still far from perfect; but the image of the objects was extremely small. The possibility of painting in this way seemed to me to have been more or less proved; and if I succeed in perfecting my process, I will hasten to make you part of it, in response to the loving interest which you have shown towards me. I will not pretend that there are not huge difficulties.

Nicéphore Niépce, *The Set Table*, c. 1832.

Above all in fixing the colours, but with some work and plenty of patience many things can be achieved. What you predicted has happened: the background of the picture is black, and the objects are white, that is to say lighter than the background. I think that this way of painting is not uncommon, and that I have seen engravings of this kind: what is more, perhaps it would not be impossible to change this placement of the colours; I even have up here some facts which I am curious to verify.

Letter from Nicéphore Niépce
to his brother Claude,
Saint-Loup, 5 May 1816

## 'That animal Daguerre'

Here's something new: Daguerre has succeeded in fixing by chemical means on a flat and white substance, which is not paper, the reflection in the camera obscura. Ah! Bizet saw, with his own eyes, one of these monochrome reflections framed. It is a view of Montmartre taken from the top of the Diorama: the telegraph and its tower are about eight *lignes* high; with a small magnifying glass you can clearly distinguish on this reproduction the crockets and pi[llars? *Gap in the text*] of the wings of the tower, the wires used to

transmit the telegraph…and other minute details invisible in the best straightforward view on the drawing itself, and which no hand or instrument would ever succeed in rendering.

Now if this is all true, as I have no reason to doubt, and if this method becomes accessible to everyone, slog your guts out, poor draughtsmen, gouge out your eyes since a Savoyard with his magic lantern is going to drive you a hundred feet under the ground!!! It is enough to drive you mad and destroy your belief in Providence, as in the end it isn't fair. Good old Bizet, whom I have just seen, has had two attacks of paralysis; his servant told me, so that he does not suspect, he calls them dizzy spells. He is a little better now, but he is much changed. He has asked me a lot for your news, and he is now starting to go out, since he had his first attack back in February. It is only in the last few days that he has seen the result of the research carried out by that animal Daguerre, so if this had happened before his illness I would have thought that he had dreamt it; but he is on the ball and the details that he gave me almost passed his dizzy spells on to me, or rather almost gave me one.

Viollet-le-Duc's father,
letter to his son in Italy,
28 September 1836

## 'A highly distinguished pupil of Faust'?

Speaking of beautiful things, I have forgotten to reply to what you wrote about M. Daguerre's new discovery. To be honest, it does not really bother me, since, despite all the respect that I have for the honesty of the good M. Bizet, I know that he sometimes deludes himself, and until I have seen it with my own eyes

(this process that is so astonishing) I will not believe it; because then my uncle Delécluze's story of the 'Mechanic king', who claims to have created a mirror with the ability to preserve the reflection of a figure in an indelible manner and in the absence of this figure, would no longer be a story but a reality. And in all honesty, one would have to be extremely naïve to believe that by chemical or alchemical means, or even magical ones (which would be needed), one could fix on a white substance, be it the lithographic stone habitually used by Solomon, the fleeting reflection of the camera obscura. I cannot imagine, unless M. Daguerre be a highly distinguished pupil of Faust or Pico della Mirandola, I cannot imagine how one could ever think that the reflection of a colour could have such a great influence over the reflecting object as to stay there… But I do not doubt it, I even admit that this could or might be. Fortunately, Providence has placed in all mechanical methods an imperfection, or rather a uniformity, which has made, and always will make, preferable to them that tool, so delicate, so poetic, of the submissive slave of thought, that capricious minister of our soul always at our service which is still called a hand, and which is still held in enough esteem not to be preferred to all mechanics from the Chaillot fire pump to the machine which spews out twelve or fifteen hundred covers a day, or 25,000 ells of tulle. When the camera obscura first appeared, didn't they say: Ah! all the drawings done by our fathers are merely course and imperfect imitations of nature, compared to what we are able to do today.…

With the result that those who did not know how to draw, draw better. Has anyone since then done any drawings that are more precise than those of Israël

Silvestre or Pannini? Once again, I am only referring to drawings whose quality lies in their precision; I even leave aside art, a long way above all that. The Dioramas of M. Daguerre, conceived to produce illusion, a fortunate mechanism to take the spectator as close as possible to nature, have Dioramas, I ask, ever enjoyed a quarter of the popularity of a good picture at an exhibition? Because the Diorama smacks of the machine, and because, people, thank goodness, have a horror of the machine.

Eugène Viollet-le-Duc replying to his father, 14 October 1836

### 'When one has come up with such an invention, it is difficult to keep it to oneself for long'

About Daguerre, I know no more than what has been published everywhere by Arago or myself. In any case, it is one of the most delightful discoveries and one which is most worthy of admiration. That has nothing in common with the effect on silver chloride; here light brings light, a process of decoloration comparable to the way in which, after several months, a grid ends up reproduced on a curtain dyed with artificial pink.

At Daguerre's, you see nothing but images framed under glass, usually on metal, a few less successful views on paper and on glass plates, all similar to engraving on steel, bistre, grey and ochre in tone, and always looking rather sad and blurred. The most beautiful gradations of half-tones, the variety of the waters of the Seine beneath the bridges, or in the middle of the river, horses, men fishing, with their shadows projected in the most precise fashion, because due to great distance, slight movements hardly have any effect, due

to the smallness of the angle. Diffuse light produces the same effect as sunlight. Beautiful reproductions of the embankments or views of Paris in the distance in rainy weather. Gradations of luminosity, the *Palais* and *Jardin des Tuileries* at five o'clock in the morning, in summer, at two o'clock in the summer heat and at seven o'clock when the sun goes down, all is captured in a single colour, monochrome. There is still no question of making the images or the portraits multiple. The most splendid effect is obtained with the aid of a lamp lighting marble statues, or marble bas-reliefs. These plates, ten inches [twenty-five cm] long and six inches [fifteen cm] high, or even larger, are remarkable under the effects of dazzling light.

Battle scenes are copied in eight to ten minutes and reduced to the size desired.

The surface of the damp stone, of the bond of the wall, has a truth which is not achieved by any copper engraving.

The overall tone is soft, subtle, but as though darkened, grey, a little sad. I was able to see an interior view of the courtyard of the Louvre with numerous bas-reliefs. – *There was some straw (which) had just been spread on the embankment. Can you see it in the picture?* – *No.* He held out a magnifying glass and I saw some wisps of straw on all the windows. In a drawing, Arago says, a house of five storeys occupied a space roughly three-quarters of an inch; you could see in the image that in a skylight – and what a triviality!! – a pane had been broken and repaired with some paper. – Arago has now obtained Daguerre's secret and has produced a perfect image before his eyes in ten minutes. The image showed a very delicate lightening conductor that Arago had not seen with his naked eye. Since it is certain that the method can be used by everyone and while travelling, there is no doubt in Paris that Arago will obtain from the Chambers, for Mr Daguerre and Niépce's widow – the widow of the co-inventor, also French – from the Chamber of Deputies, the two hundred thousand francs required. Subsequently, in conformity with the noble traditions that reign there, the government will make the invention public. What an advantage for architects to be able to take away the whole of the colonnade at Baalbek or the bric-à-brac of a Gothic church in ten minutes in one image. Daguerre believes that the intensity of the light in Egypt should act in two to three minutes....

Such are the hopes that the contemplation of the products – the images – arouses today. What improvements future use will produce, it is impossible to predict. How many refinements were made to lithography after lengthy usage revealed in it more than one defect. Quite rightly, Daguerre is extremely afraid that the discovery will be detected. It is a visit (*sic* – visual?) thing so simple that it should have been discovered a long time ago, nevertheless I have been working on it for twelve years and have not succeeded in doing anything until the last few months. What if the good abbot of Schmalkald, what if Fox Talbot, who wrote me a letter which explains nothing, really succeed in producing accurate images? We shall see. I am inclined to believe that when one has come up with such an invention, it is difficult to keep it to oneself for long.

Alexandre von Humboldt,
letter to Carus, Paris,
25 February 1819

# The photographer-entrepreneur

*Company manager and man of the world, the great studio portraitist became, during the 1850s, a regular in the columns of the newspapers: while the majority of these articles were primarily interested in the worldly aspect, happy to conjure up the 'artist' at work, more specialized magazines focused on the running of the studio, tackling photography from a financial and industrial point of view.*

### The opening of Brady's new gallery

At the corner of Broadway and Tenth street, Brady has reappeared on a scale and after a fashion which strikingly illustrates the development of photography into a colossal industry worthy to take its place with the most significant manufactures of the country. The prosperity which Brady has now opened, throws a marvelous light upon the means which we shall bequeath to our posterity of knowing what manner of men and women we Americans of 1860 were. All our books, all our newspapers, all our private letters – though they are all to be weighed yearly by the ton, rather than counted by the dozen – will not so betray us to our coming critics as the millions of photographs we shall leave behind us. Fancy what the value to us would be of a set of imperial photographs of the imperial Romans? How many learned treatises we would gladly throw into the sea in exchange for a daguerreotype of Alexander the Great, as he sat at the feast with 'lovely Thais', or an ambrotype of Cleopatra as she looked when she dropped that orient pearl into her cup with sumptuous grace!

Well, these we shall never have: but in default of them, our children's children may look into our very eyes, and judge us as we are. Perhaps this will be no great advantage to us, but, in our children's children's name, we ought to thank Mr Brady and those who labor with him to this end.

The new Brady Gallery has been baptized the 'National Portrait Gallery'. It deserves the name, and more. It is cosmopolite as well at [sic] national. The ample stairway of rich carved wood introduces you to a very Valhalla of celebrities, ranging over two continents, and through all ranks of human activity. Had we a Balzac among us, his creditors might be sure te [sic] catch him in Mr Brady's gallery, for all types of New York and America have given each other a *rendezvous* in this *Ruhm-Halle*, or Hall of Renown. In this deep-tinted luxurious

room, are gathered the senators and the sentimentalists, the bankers and the poets, the lawyers and the divines of the state and of the nation, kept all in order and refined by the smiling queenliness of all manner of lovely or celebrated women. Hostile editors here stand side by side, on their best behavior, stately diplomats make themselves pleasant in the very presence of undiplomatic Garibaldi; the Emperor of the French receives the editor of the London *Times* with unruffled [*sic*] brow. If the men themselves whose physiognomies are here displayed would but meet together for half an hour in as calm a frame of mind as their pictures wear, how vastly all the world's disputes would be simplified; how many tears and troubles might mankind be spared!

*American Journal of Photography
and the Allied Arts and Sciences,
n. s., 3, No. 10, 15 October 1860*

An advertisement for Pierre Petit's studio, c. 1870.

## A few words on photography from the industrial point of view

There is a point of view from which photography has been ill considered up till now: that of its industrial development, which has, nevertheless, its own importance. Looking at the considerable quantity of prints, either stereoscopic or others, which are put on sale every day, one can hardly imagine the enormous amount of work they represent, the number of hands they have passed through before becoming available to buyers, nor the place that the studios which produce them occupy in modern Paris. It is, however, an interesting question and one well worth examining.

When one visits, for example, the store owned by the Gaudin brothers, one is astonished by the number of prints there, which are not exactly piled up, for that would imply a sense of disorder that is clearly false, but grouped together and put into categories. Everywhere is filled with them: display cabinets arranged like libraries, drawers, boxes – like boats both in shape and size – baskets, tables and even the stereoscopes themselves. Every subject, every character, every country is represented there, in thousands of examples. Each series makes up a catalogue which is the size of a large book, and this wealth of prints is constantly increasing and replenished. Customers who have spent hours looking at one example after another, and who have only seen one hundredth of this museum, are undoubtedly astonished, but would be even more so if they realized the work that had gone into each of the collections passing before their eyes.

A few days ago, we visited the new studios which the Ferriers, father and

son, recently working in association with M. Soulié, have established on the Boulevard de Sébastopol, and this visit allowed us a glimpse into the importance of the industrial aspect to which we are referring. For a long time we have appreciated and loved these artists who are so industrious and skilful, we were aware that they produced a lot, but we were far from doubting all the activity surrounding them. Alongside the vast shop where the prints, arranged symmetrically in numbered drawers, are presented to clients, stretches a row of rooms where people are busily working. Here are the laboratory, then the preparation room, then the one in which the printing takes place; important operations that are continuously supervised by M. Ferrier himself. At the end of the day, all the positive prints obtained during the course of the day – a considerable number – are handed on to others and developed during the evening, in a special room. A man carries out the fixing and rinsing in a neighbouring room. Once completed, the positive prints on glass are passed on to workers who cut them, while others apply tarnished glass; then they are examined one by one, a paintbrush being used in order to correct any slight imperfections; the women then take them and clean them, others frame them and, finally, if there is room, stick on the explanatory captions.

So, briefly, this is what we saw. The establishment occupies no more than eight or ten large rooms, and employs fifteen or so people, without counting those who work externally.

We ask ourselves how many of those who, in a salon, admire a stereoscopic view of Italy, Spain or Switzerland, are aware of all the channels it has gone through, and the number of hands it has set in motion before getting there? – This question is not without interest, as one can see, from the point of view of modern industry and its progressive growth.

*Le Moniteur de la photographie*, 1859

## A visit to Nadar's studio

The building it occupies opens onto a long hallway which is entered by a double glass door and hung with frames in which various samples are displayed. On the left is a large salon adorned with beautiful paintings representing the different phases in the celebrated ascension of the *Giant*. Antiques, expensive china (Nadar is one of our greatest collectors in this field) attract the visitor's attention. On the right of the hallway is the saleroom. At the end, curtains made of old tapestry, always left open, allow a view into the main room which, alone, occupies the whole of the ground floor. This vast room, which resembles one in a museum, is lit from above; a sort of gallery, formed by the same columns which support the ceiling, surrounds it on three sides. It is here that the public is taken and where people wait, entirely undisturbed, their turn to sit. In order to entertain their eyes and their spirit, it is full of exquisite paintings, interesting albums, rare flowers, objects of art of all kinds. But, above all, visitors are interested in watching Vieusseux, the skilful painter attached to the establishment, at work. Imperturbable under the gaze of those following his brush, the artist is parked in one of the corners of the immense salon. His setup consists of his paint box and palette; under his hand, the print enlarged on canvas or paper is transformed into a splendid painting in oils or into a ravishing life-size

watercolour. He excels particularly in the latter genre, and quite rightly there is great admiration for the truly extraordinary effects he succeeds in extracting from the watercolours for works of similar dimensions. These portraits of the head and shoulders cost from 1000 to 2000 francs, while full length costs from 3000 to 4000 francs; but, here, the public does not consider the expense, as they are real masterpieces.

When it is time for the sitting, one goes up to the first floor, where the terrace and the laboratories are situated; ladies who wish to make adjustments to their toilette, can stop first on the mezzanine floor, where a large boudoir is set aside for their use. Here the private apartments of Nadar and his family are also situated, and, to the rear of the building, are the studios where the negatives and positive prints are retouched, the cylinder presses, and lastly the rooms of the principal employees who are lodged in the establishment. On the second floor is the large studio, which is no less than 14 metres long by 12 wide [about 46 by 40 feet], and with an average height of 3 metres [about 10 feet]. The window, which is straight and not with an inclined roof, as is generally found, is adorned with three rows of curtains, manoeuvrable in all directions, in blue cretonne and muslin, slightly grey.

A small chamber on wheels, also equipped with a double row of curtains,

NADAR LE GRAND (!!!...)

$A$ cartoon by A. Grévin showing Nadar the Great, c. 1865.

can be moved around and allows, according to the season, the hour and the type of sitter, for the sitter to be lit from all aspects and all angles, ranging from direct lighting to various low-angled lights and to what is known as 'the footlights'.

Large canvases in the background, produced by the brushes of the best decorators in Paris, represent the most varied subject matter in trompe-l'oeil.

This huge terrace receives plenty of light from the north, east and west.

Ernest Lacan,
'Une visite chez Nadar, rue d'Anjou',
*Le Moniteur de la photographie*,
1 December 1876

# Photographic exploits

*Outside the studio, the weight of the equipment made photography difficult (a portable photographic laboratory; opposite below). In certain circumstances, it also proved to be a real feat. From the Crimean War to the exploration of the American West, some rare diaries and accounts of photographers' journeys convey the heroic aspect of photography during the period between 1850 and 1870.*

**'The glare was so great from the sky and burnt-up ground' (Fenton)**

It was necessary in the hot weather to thin the collodion to a much greater extent than is usual in England; and even with this precaution it was hard to spread a film of collodion evenly over a large plate, the upper part of the plate drying before the excess of liquid had run off at the lower end of the plate. From the same cause the development of the pictures was more difficult, as the film often became nearly dry in the short time necessary to take the slide containing it to the camera and back again, and then of course the developing fluid would not, when poured on to the plate, run at once all over it without stoppage. Some idea of the heat may be formed from the fact, that the door of the van being one day in the beginning of June left open, and the sun shining into it, a gutta-percha funnel, which was exposed to its rays, became blistered all over as if it had been laid upon the heated bars of a fireplace. I need not speak of the physical exhaustion which I experienced in working in my van at this period. Though it was painted a light colour externally, it grew so hot towards noon as to burn the hand when touched. As soon as the door was closed to commence the preparation of a plate, perspiration started from every pore; and the sense of relief was great when it was possible to open the door and breathe even the hot air outside.

I should not forget to state that it was at this time that the plague of flies commenced. Before preparing a plate, the first thing to be done was to battle with them for possession of the place; the necessary buffeting with handkerchiefs and towels having taken place, and the intruders being expelled, the moment the last one was out, the door had to be rapidly closed for fear of a fresh invasion and then some time to be allowed for the dust thus raised to settle before coating a plate.

Eventually, I was obliged in the month of June, to cease working after 10 o'clock in the morning. Without reference to the fatigue which would have resulted from work during the heat of the day, it would have been impossible, so far as portraits are concerned, to take any satisfactory ones after that hour, for the glare was so

great from the sky and burnt-up ground, that no-one could keep his eyes more than half open.

Robert Fenton,
*Narrative of a Photographic Trip to the Seat of the War in the Crimea*,
Report to the Royal Photographic Society, January 1856

### Gusts of wind and flurries of snow (the Bisson brothers)

Before finally reaching the summit, on 26 July 1861, Auguste Rosalie had already made two earlier attempts, on 16 August 1859 and 3 September 1860.

The previous summer, the famous photographers, the Bisson Frères, also wished to attempt the ascent of Mont Blanc, purely and exclusively from the point of view of their art. On the morning of 16 August, the caravan consisting of 25 porters and guides left Chamonix. The leaders of the expedition were the guides Michel-Auguste Balmat and Mugnier. The main items of baggage to be transported to the summit were a tent and a voluminous piece of apparatus meant for taking panoramic views; these items, dismantled, were distributed with the rest of the baggage among the various porters. Favorable at first, the weather gradually worsened during the day. Following one of those brusque changes so frequent in the Alps, the caravan, caught up in the middle of the glaciers, was assailed by rain and snow; at four o'clock it arrived at the rocks known as the Grands-Mulets, situated in the middle of the ice field which descends from various summits of Mont Blanc and where, for several years now, a hut has been set up to serve as a shelter for spending the night. The snow having fallen, and the bad weather destroying the hope of being able to carry all the apparatus to the top of Mont Blanc the next day, M. Bisson left the Grands-Mulets at three in the morning with four guides to attempt the ascent, so as to acquaint himself with the difficulties, and to study in what conditions the panoramic view, which he had been

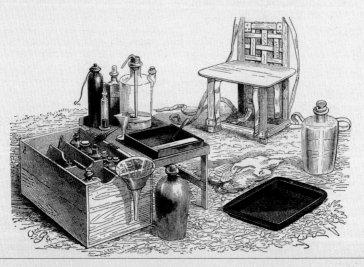

forced to postpone due to unfavourable circumstances, could eventually be taken.… The thermometer was then showing zero. Higher up, under the influence of the wind blowing from the north, it fell still further, descending to 12 degrees as they approached the summit. In order to climb a final slope of ice, approximately two hundred steps had had to be cut with an axe. This difficult step was overcome; the view, dominating the southern face, opposite to that overlooking the Chamonix valley, plunged into the precipices on the Courmayeur side. They had reached the last rocks below the summit.

Just a little more effort and very shortly they would reach their desired goal; but the gusts of wind, stirring up flurries of snow, became so violent that they destroyed any hope of being able to remain on the summit, and they were making the descent increasingly difficult and dangerous. They had to resign themselves. Nevertheless, so much effort and, it has to be said, so much expense, were not completely wasted. Although the Bisson brothers had not been able to take, as they had planned, a complete view taken from the top of Mont Blanc, they were at least able to take away some views of details, gathered in the upper regions of the glacier. This is a whole new world they are about to show us.

<div align="right">A. J. du Pays,<br>
'Les Frères Bison au Mont Blanc',<br>
<em>L'Illustration</em>, 7 January 1860</div>

### Nadar and aerostatic photography

These attempts were very expensive and presented too many difficulties to be repeated and followed up as they should have been. I also needed to earn my daily bread; such an ascent could not be improvised, and while I was in the air, my photography studio suffered.

The greatest, perhaps the only true obstacle to my success, was the aerostatic apparatus itself that I was forced to employ.

The fairground balloons that I used, in the absence of anything more specific, which would have been costly to set up and hence prohibitive for me, these balloons, basically too short, spewed streams of hydrogen sulphide out of their open appendage, straight on to my dishes – and the worst student photographer would explode imagining the mixture my iodides must have made with that devilish gas. It was the same as testing out embers at the bottom of a bucket of water.… I was in despair – and I let go, nevertheless.… Once, following the latest failure, I gave the order as I had done on previous occasions to abandon all. Like the confectioner who eats all his left-overs, after each unsuccessful photographic attempt, I offered myself the pleasure of a free ascent.

An hour later we descended into an enchanting and deserted valley known as the Vallée de la Bièvre, at Petit-Bicêtre, two or three leagues from Paris. There was no wind – and a carriage I had hired deliberately brought my assistant and my servant at practically the same time as us to the site of the descent.

I made a resolution:
'We are going to leave the balloon here, closing its opening. There is no danger since the gas will not expand tonight, on the contrary. I will go up again tomorrow morning at first light, with some fresh baths brought expressly – and we shall see....'

Returning to the place the next morning: the weather was cloudy, a grey and icy mist had fallen. So what!

The nacelle was emptied: I climbed in. The balloon rose a metre and sank again. The gas had lost its strength during the night and, what is more, the wires and rigging were weighed down by the dew and the fine rain which fell so inopportunely.

I did not want to despair. I emptied the nacelle of all that I could take out...and I rose to approximately 80 metres [26 feet].

I had taken my plate, prepared in advance. I opened and closed the shutter, and cried with impatience: Bring me down!

I was pulled back down to the ground, and with a single bound leapt into the inn where, trembling, I developed my image.

What joy! – There was something there!

I insisted and persevered; the image was revealed, extremely faded, extremely pale, but sharp and clear.

It might only have been a simple positive on glass, very faint, all stained, but who cared! I emerged triumphant from my improvised laboratory.

It is impossible to deny! There were the only three houses making up the tiny village known as the 'Petit Bicêtre': a farm, an inn and the police station.... The tiles on the roofs were clearly distinguishable, as was a carpet on the road where the carter had stopped short in front of the balloon.

I had been right! Aerostatic photography was possible – whatever the most reputable of my colleagues might have said to discourage me initially!

Nadar,
*Mémoires d'un géant*, 1864

## Bell and his photographic mule

I arise at 4 a.m.; feed the mule; shiver down my breakfast; mercury at 30°, candle dim, cup and plate tin; my seat, the ground. After breakfast I roll up my bedding, carry it up to be loaded on the pack mule, water and saddle my riding mule, and by that time it is broad daylight. If negatives are to be taken on the march the *photographic* mule is packed with dark-tent, chemical boxes and camera, and out we start...having found a spot from whence three or four [views] can be had, we make a station, unpack the mule, erect the tent, camera, etc. The temperature has risen from 30° to 65°. One finds difficulty in flowing a $10 \times 12$ plate with thick enough collodion to make a sufficiently strong negative without redevelopment, and to have a plate ready for development that has not dried on account of the distance the plate has been carried, and [the] time intervening between sensitizing and development... these troubles are constant.

William Bell,
'Photography in the Grand Gulch of the Colorado River',
*The Philadelphia Photographer* 10, No. 109, January 1873

# Photographic fantasies

*From the moment it appeared, photography gave rise to reveries and fantasies. Some observers emphasized the magical nature of the photographic act, while others speculated on its – actual – capacity to capture phenomena up until then invisible to people. Many of these beliefs were exploited during the 1860s by spiritualist photography.*

## The 'Mental Daguerroscope'

I have recently returned from a flying trip to London.... I shall not trouble you with a tedious description of my voyage, but will commence with a time when – I had seen most of the 'great attractions' of the metropolitan city, and was merely gleaning the field from which I had already gathered abundantly, as I one morning espied over a door a small sign with this inscription – 'Mental Daguerroscope'. Something new under the sun! Just what I came all the way to London to see – and I immediately walked in. The room which I entered exhibited about equally the appearance of a chemical laboratory, and an ordinary engraver's office. Here was an electrical machine, and there an engraver's stone – here a galvanic battery, and there a pile of designs; with a countless number of other things, presenting in itself a sight, no doubt as curious as the workshop of 'Jabez Dolittle', but when compared with the wonderful results of the art which I afterwards saw there, it was nearly forgotten. Upon my making some inquiries respecting this art, of which I had never before heard, I was informed that it was a new method of taking impressions of objects, which method had first been suggested to the author by the lunar Daguerroscope. He said they would soon take an impression, in seeing which, I might obtain a better idea of the process than by any description he could give. A sheet of drawing-paper which had received the solution preparatory to taking an impression was first placed in a perpendicular position. In front of this was seated the engraver, for so he was called, in a large arm-chair, covered with a kind of cloth which had rendered it nonconductoral of the electric fluid; his dress was of the same material. He was now thrown into a profound 'magnetic slumber', and while in this condition was charged with electric fluid until his eyes flashed open. He immediately fixed them upon me, and that with such an unearthly glowing, that I could think of nothing but his satanic majesty, and began to retreat. Just as I moved, he took his eyes from me and fixed them upon the paper before him, and I saw in art instant my own likeness there, in its full and perfect proportions. As fast as the impressions were taken, the sheet was removed and a new one substituted, until they became so faint as to be scarcely perceptible. This was the

'mental Daguerroscope'. There is no part of it secret except the preparation of the paper previous to being engraved upon. I was now shown several specimens of landscape engravings by the same method, which rivalled everything in that line, as much as nature has heretofore excelled the most bungling productions of art. The lunar Daguerroscope has reached perfection in this establishment, as you will readily believe when I tell you that, in taking the landscape impression a few days since, a perfect human figure, with long flowing hair, and a fine pair of wings, appeared, flying through the air at a little distance from the earth. Unseen by mortal eyes, unknown his presence; from whence, or whither bound, all a mystery; yet leaving his shadow to gladden our hearts with the belief that good spirits hover over us.

Anonymous,
*The New York Mirror:
A Weekly Journal of Literature and
the Fine Arts*, Vol. 17, No. 4,
20 July 1869

### Ghosts, in superimposed layers

Balzac felt ill at ease with regard to the new wonder: he was unable to fight off a vague apprehension of the Daguerrean method.

He had found his own explanation for it, somehow at the time, in the same vein as the fantastic hypotheses *à la* Cardan. I seem to recall having seen him express his particular theory in full somewhere in the midst of his vast oeuvre. I do not have the time to look for it, but my recollection is very clear and based on the lengthy account he gave during one of our meetings and which he repeated to me on another occasion, for he seemed obsessed by it, in the small apartment with purple hangings where he lived at

the corner of the Rue Richelieu and the Boulevard: that building, famous as a gambling house during the Restoration, still went by the name of the Hotel Frascati at the time.

So, according to Balzac, each body in nature consists of a series of ghosts, in an infinity of superimposed layers, foliated in infinitesimal films, in all the directions in which optics perceive this body.

Man being destined never to create – that is to say, make something solid of an apparition, of the impalpable, or to make something from nothing – each Daguerrean operation was therefore going to surprise, detach and retain one of the layers of the body on which it focused.

From then onwards, and every time the operation was repeated, the subject in question evidently suffered the loss of one of its ghosts, that is to say, the very essence of which it was composed.

Was this an absolute, definitive loss, or was this partial loss repaired consecutively in the mystery of a more or less instantaneous rebirth of the ghostly material? I imagine that once he got going Balzac was not a man to be deterred, and that he had to follow the path of his hypothesis to the end. But we never tackled the second point.

But was Balzac's terror with regard to the Daguerreotype sincere or faked? If he was being sincere, Balzac had only to gain by losing, his fullness in the abdominal region and elsewhere allowing him to give his 'ghosts' unsparingly. In any case, it did not prevent him from sitting at least once for the unique Daguerreotype I possessed by Gavarni and Silvy, now belonging to M. Spoelberg de Lovenjoul.

Nadar,
'Balzac et le Daguerreotype',
*Quand j'étais photographe*, 1901

### In the eyes of the dead

A few weeks ago, a murder was committed in London. The victim was a young woman, and the police have not yet discovered who carried out this atrocious act. Mr Warner, a photographer in Ross, has written on the subject to the chief of police in London to remind him that if the eyes of a murdered person are reproduced through photography, it is possible to make out on the print the image of the last object to pass in front of the eyes before death. This image is situated on the retina, and the success of the operation requires the print to be made as soon as possible after the death. This is not mere theoretical speculation on the part of Mr Warner. Four years ago, the author took the negative of a cow's eye several hours after its death and, examining this print under the microscope, he clearly saw the straight lines of the stone floor of the abattoir! So therefore the cow did not see the butcher! Mr Thomson, an officer in the London police force, knew four years ago that if a dead person's retina is photographed, it is possible to make out the image of the last thing seen by that eye; but the print must be produced within twenty-four hours of death, otherwise the image gradually fades, like that of a negative exposed to sunlight before being developed.

*Le Moniteur de la photographie*, 1863

### 'Buguet the medium allows the Spirits to act'

For some time now we have heard it said that one can obtain spiritualist photographs from M. Buguet at 5, Boulevard Montmartre in Paris. For some it was a secret and, to tell the truth, hearing what has been said about the subject, one might have believed that Messieurs X…had invented the photographer and spiritualist photography. A month ago at most, our friend M. Véron brought us some remarkable specimens, and we went to M. Buguet's as soon as we could : we discovered him to be an artist without pretension, extremely amiable, who was very aware of his ability for what it is, that is to say a pure and simple act using the powers of a medium.

We found ourselves in the company of several people who had come to have a print made: a glass bought from a dealer was cut with a diamond and the detached piece was placed in the pocket of an assistant; polished and prepared with the usual silver bath, a bath commonly used by all photographers, we brought it back up again to give it to M. Buguet, the cameraman, who focused the lens after having arranged the pose. The wall-covering behind the person to be photographed was paper, the instrument employed was the ordinary lens which we had been able to inspect both inside and out. We were ordered to be quiet and calm, M. Buguet made some sort of mental evocation, concentrated and the print, or four prints successively obtained from the same shot, were taken to the laboratory where the medium developed them in front of five other people; one of the assistants and M. Leymarie had each posed twice in quarter of an hour. On this plate which had had a corner removed and which was perfectly adapted, there were the traces of Spirits. These various manipulations or chemical operations, we repeat, were followed by five attentive people, the Spirits had half their face veiled.

The next day, Messieurs Véron, Gaillard, artist at the Opéra, and Mme X…had a try under the same conditions. The father of this lady appeared on four prints, changing his pose each time. Thus, this Spirit, which materialized in a remarkable manner, had some drapery on his head, his face was uncovered and in profile, his right hand clearly characterized and placed on his daughter's heart. M. Véron, who posed twice, had behind him the same Spirit, but without white drapery he placed his hand in the middle of his face, a diaphanous hand leaving the traits of M. Véron visible, the Spirit's physiognomy being seen face on. On the third print, the Spirit places one hand on his chest, the other blesses M. Véron. Lastly, M. Galliard has the same character close to him, he holds his white drapery over his arm, while with the right hand he is throwing some liquid on his head. This print is quite extraordinary, in the sense that it is the image of a man who died some time ago, and of whom no portrait exists, that this spirit, in the space of fifteen minutes, has taken fluidic clothes and assumed different poses while maintaining the same physiognomy.…

To our correspondents and friends, Céphas, Marc Baptiste, S-D., in Roubaix, etc., etc., we shall say: Buguet the medium allows the Spirits to act; the plate prepared by the first to arrive is placed in the lens, and he prays; the deeper his concentration, the more he is shaken and exhausted; in the strength of this shock he senses the presence of the Spirit. No shock, no result. Often, after several experiments, he is so weakened that he slumps and falls exhausted, incapable of doing anything; it seems as though a vital fluid has been extracted from his nervous system, and then an acknowledged magnetization releases him and allows him to wait for the next day, to sleep, to be capable of starting all over again.

M. Buguet charges 20 francs, the same as an ordinary photograph; he provides six prints. It would be desirable that people wanting to pose should arrange the day and time with him beforehand; that one should not ask him a multitude of useless questions, since the Spirits have not revealed their secret to him; that a religious silence should exist for the duration of the operation; lastly, that the community of thought must reign, that force helping the molecular release which serves in the materialization of the invisible. As far as possible, do not be too numerous, curiosity being something futile in the face of a phenomenon of this magnitude.

Anonymous,
'La Photographie spirite à Paris',
*Revue spirite, Journal d'études psychologiques*, January 1874

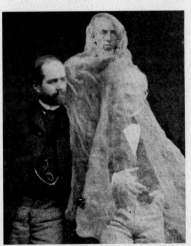

Photograph from the cover of *La Revue spirite*, June 1874.

# Is photography an art?

*A simple servant of the arts or an entirely separate art? During the 1840s, this question was widely debated and gave rise to numerous publications. The initial interest in, or even infatuation with, photography was followed, it seems, by a gradual disenchantment in artistic circles with the new technique, perfectly discernible in the development of someone like Ruskin.*

### 'It is a noble invention' (Ruskin)

I have been lucky enough to get from a poor Frenchman here, said to be in distress, some most beautiful, though very small, Daguerreotypes of the palaces I have been trying to draw; and certainly Daguerreotypes taken by this vivid sunlight are glorious things. It is very nearly the same thing as carrying off the palace itself; every chip of stone and stain is there, and of course there is no mistake about proportions. I am very much delighted with these, and am going to have some more made of pet bits. It is a noble invention – say what they will of it – and any one who has worked and blundered and stammered as I have done for four days, and then sees the thing he has been trying to do so long in vain, done perfectly and faultlessly in half a minute, won't abuse it afterwards.

John Ruskin,
letter to his father from Venice,
7 October 1845

My drawings are truth to the very letter – too literal, perhaps, so says my father, so says not the Daguerreotype, for it beats me grievously. I have allied myself

with it; sith [*sic*] it may no better be, and have brought away some precious records from Florence. It is certainly the most marvellous invention of the century; given us, I think, just in time to save some evidence from the great public of wreckers. As regards art, I wish it had never been discovered, it will make the eye too fastidious to accept mere handling.

John Ruskin,
letter to W. H. Harrison
12 August 1846

### 'They supersede no good art' (Ruskin)

Let me assure you, once for all, that photographs supersede no single quality nor use of fine art, and have so much in common with nature, that they even share her temper of parsimony, and will themselves give you nothing valuable that you do not work for. They supersede no good art, for the definition of art is 'Human labour regulated by human design,' and this design, or evidence of active intellect in choice and arrangement, is the essential part of the work; which so long as you cannot perceive, you perceive no art whatsoever;

which when once you do perceive, you will perceive also to be replaceable by no mechanism. But, farther, photographs will give you nothing you do not work for. They are invaluable for record of some kinds of acts, and for giving transcripts of drawings by great masters; but neither in the photographed scene, nor photographed drawing, will you see any true good, more than in the things themselves, until you have given the appointed price in your own attention and toil. And when once you have paid this price, you will not care for photographs of landscapes. They are not true, though they seem so. They are merely spoiled nature. If it is not human design you are looking for, there is more beauty in the next wayside bank than in all the sun-blackened paper you could collect in a lifetime.

John Ruskin,
*Lectures on Art*, Vol. 20, 1870

## 'A sort of dictionary' (Delacroix)

Many artists have had recourse to photography to redress the errors of the eye: I would support them, and perhaps contrary to the opinion of the critics of the method of teaching by the cast in the window or in gauze, that the study of the daguerreotype, if it is well understood, can itself alone remedy the deficiencies in the teaching; but it is necessary already to have great experience in order to draw help from it properly. The daguerreotype is more than the cast, it is the mirror of the object; certain details, almost always neglected in drawings from nature, assume in it a great characteristic importance, and introduce thus the artist into the complete knowledge of the construction; the true character of light and shade are to be found in it, that is to say with the exact degree of firmness or softness, an extremely fine distinction

without which there would be no depth. It must not be forgotten, however, that the daguerreotype should not be considered as a translator responsible for initiating us earlier into the secrets of nature; for, despite its astonishing reality in certain areas, it is still only a reflection of reality, a copy, false in a certain way due to its being exact. The monstrosities it offers are shocking and rightly so, although they may literally be those of nature herself; but these imperfections which the machine reproduces faithfully are not shocking to our eyes when we look at the model without this intermediary; without us knowing, the eye corrects the awkward exactitudes of rigorous perspective; it already carries out the work of an intelligent artist: *in painting, it is the spirit that communicates with the spirit and not science that communicates with science.* This remark by Mme Cavé is the old argument between the letter and the spirit: it is the criticism of those artists who, rather than taking the daguerreotype as a guide, as a sort of dictionary, turn it into the picture itself. They believe they are much closer to nature when, through effort, they have not spoilt too much in their painting the result obtained initially by mechanical means. They are crushed by the maddening perfection of certain effects they find on the metal plate. The more they struggle to reproduce it, the more they discover their failings. Their work is therefore merely the necessarily frigid copy of that copy which, in other eyes, is imperfect. In other words, the artist becomes a machine harnessed to another machine.

Eugène Delacroix,
'Le Dessin sans Maître,
par Mme Elisabeth Cavé',
*Revue des Deux Mondes*, September 1850

## 'The very humble servant' (Baudelaire)

During this lamentable period, a new industry arose which contributed not a little to confirm stupidity in its faith and to ruin whatever might remain of the divine in the French mind. The idolatrous mob demanded an ideal worthy of itself and appropriate to its nature – that is perfectly understood. In matters of painting and sculpture, the present-day *Credo* of the sophisticated, above all in France (and I do not think that anyone at all would dare to state the contrary), is this: 'I believe in Nature, and I believe only in Nature (there are good reasons for that). I believe that Art is, and cannot be other than, the exact reproduction of Nature (a timid and dissident sect would wish to exclude the more repellent objects of nature, such as skeletons or chamber-pots). Thus an industry that could give us a result identical to Nature would be the absolute of art.' A revengeful God has given ear to the prayers of this multitude. Daguerre was his Messiah. And now the faithful says to himself: 'Since Photography gives us every guarantee of exactitude that we could desire (they really believe that, the mad fools!), then Photography and Art are the same thing.' From that moment our squalid society rushed, Narcissus to a man, to gaze at its trivial image on a scrap of metal. A madness, an extraordinary fanaticism took possession of all these new sun-worshippers. Strange abominations took form. By bringing together a group of male and female clowns, got up like butchers and laundry-maids at a carnival, and by begging these *heroes* to be so kind as to hold their chance grimaces for the time necessary for the performance, the operator flattered himself that he was reproducing tragic or elegant scenes from ancient history. Some democratic writer ought to have seen here a cheap method of disseminating a loathing for history and for painting among the people, thus committing a double sacrilege and insulting at one and the same time the divine art of painting and the noble art of the actor. A little later a thousand hungry eyes were bending over the peepholes of the stereoscope, as though they were the attic-windows of the infinite. The love of pornography, which is no less deep-rooted in the natural heart of man than the love of himself, was not to let slip so fine an opportunity of self-satisfaction. And do not imagine that it was only children on their way back from school who took pleasure in these follies: the world was infatuated with them....

As the photographic industry was the refuge of every would-be painter, every painter too ill-endowed or too lazy to complete his studies, this universal infatuation bore not only the mark of a blindness, an imbecility, but had also the air of a vengeance. I do not believe, or at least I do not wish to believe, in the absolute success of such a brutish conspiracy, in which, as in all others, one finds both fools and knaves; but I am convinced that the ill-applied developments of photography, like all other purely material developments of progress, have contributed much to the impoverishment of the French artistic genius, which is already so scarce.... If photography is allowed to supplement art in some of its functions, it will soon have supplanted or corrupted it altogether, thanks to the stupidity of the multitude which is its natural ally. It is time, then, for it to return to its true duty, which is to be the servant of the sciences and arts – but the very humble servant, like printing or shorthand, which have neither created

nor supplemented literature. Let it hasten to enrich the tourist's album and restore to his eye the precision which his memory may lack; let it adorn the naturalist's library, and enlarge microscopic animals; let it even provide information to corroborate the astronomer's hypotheses; in short, let it be the secretary and clerk of whoever needs an absolute factual exactitude in his profession – up to that point nothing could be better. Let it rescue from oblivion those tumbling ruins, those books, prints and manuscripts which time is devouring, precious things whose form is dissolving and which demand a place in the archives of our memory – it will be thanked and applauded. But if it be allowed to encroach upon the domain of the impalpable and the imaginary, upon anything whose value depends solely upon the addition of something of a man's soul, then it will be so much the worse for us!

Charles Baudelaire,
'Le Public moderne et la Photographie',
*Salon de 1859*, trans. and ed. Jonathan
Mayne in *Art in Paris 1845–1862: Salons
and Other Exhibitions Reviewed by
Charles Baudelaire*, 1965

### 'The negative only conveys death' (Redon)

1876 – Photography used solely for the reproduction of drawings or bas-reliefs seems to me to be in its true role, for the art which it helps and assists, without leading it astray.

Imagine museums reproduced in this way. The mind refuses to calculate the importance painting would suddenly assume placed thus in the terrain of literary power…and of the new security assured to it in time.

Greed – folly perhaps – ardour or the unbridled passion of success or achievement have demeaned the artist to the point of debasing in him the touch of beauty.

He directly and shamefully uses photography in order to convey truth. He believes – in good faith or otherwise – that this result is sufficient when it can merely provide him with a fortuitous accident of a crude phenomenon. The negative only conveys death. The emotion felt in the presence of nature itself will always supply him with an equally authentic amount of truth, the only truth, which he, himself, controls. The other is a dangerous communication. I have been told that Delacroix advocated it: I am absolutely astonished. His statement remains to be verified.

Odilon Redon,
*À soi-même*,
*Journal, 1861–1915*, 1961

### 'The black clothing of things' (the Goncourts)

4 June 1857
At the Hôtel Drouot saw the first sale of photographs. Everything is becoming black in this century: photography is like the black clothing of things.

14 January 1861
Sometimes, I think the day will come when people will have a God, a God who will humanly have been and about which there will be the testimonies of the local papers. In the churches, the image of this God or Christ will no longer be flexible and dependent on the imagination of painters, or floating on Veronica's cloth, but a photographic portrait. Yes, I imagine a God in a photograph, who will be wearing glasses! On that day, civilization will be at its peak!

Edmond and Jules de Goncourt,
*Journal*, 1887–96

# GLOSSARY

**albumen print** Made from fresh egg white, albumen was widely used in photography from the end of the 1840s: initially in the albumen glass negative process invented by Niépce de Saint-Victor in 1848, which had the advantage of providing a more accurate image than one obtained from paper negatives, despite lengthy exposure times; subsequently, and above all from 1850 onwards, with the widespread adoption of albumen-coated paper, a printing technique invented by Blanquart-Evrard: thin, good-quality writing paper coated with salted albumen was sensitized with silver nitrate, which gave the print a smooth, glossy appearance. The tone of the prints varied, ranging from yellowish to brown and even purplish hues. Although the process was at the height of its popularity during the 1860s and 1870s, it continued to be used right up to the beginning of the 20th century.

**ambrotype** Process invented in 1852, based on the collodion process. The ambrotype was a collodion negative on glass that was under-exposed at the time it was taken and then chemically treated. The image was subsequently displayed against a dark ground, against which it appeared positive. During the second half of the 1850s, this inexpensive process rivalled the daguerreotype in popularity (particularly in the United States), imitating the way the daguerreotype was presented, in a case.

**calotype** or **talbotype** From the Greek *kalos*, meaning 'beautiful'. The name given by Fox Talbot to the negative-positive process on paper that he invented in 1840 and patented a year later. This process was the basis for all the other negative-positive processes that subsequently emerged; it propelled photography into the era of the multiple image. The negative, obtained on writing paper sensitized with silver nitrate, was usually printed with the aid of the salted paper process: the paper, sensitized with silver chloride, was recovered from the negative and exposed to the light, the image gradually forming during the exposure, before being toned and fixed. The resulting prints, ranging from sepia to black, were characterized by their matt appearance and their slightly blurred contours, making the technique unsuitable for commercial use in the field of portraiture. At the end of the 1840s, the process was improved in several ways, notably by Blanquart-Evrard; it continued to be used, mainly by amateurs, until the 1860s.

**carbon print** Invented by Alphonse Poitevin in 1855, the carbon print process, using bichromated gelatin and carbon powder, provided highly resistant images in which the blacks were extremely dark. The process was subsequently improved by various inventors, before being patented by the Englishman Joseph Wilson Swan in 1864.

**carte-album** or **cabinet photograph** First appearing in the mid-1860s, the carte-album format (approximately $16 \times 11$ cm; $6\frac{1}{4} \times 4\frac{3}{8}$ in.), slightly larger than the *carte de visite* format, was particularly suited to full-length portraits; it was used right up to the end of the 19th century. It is sometimes known in English as the 'cabinet' photograph.

**carte de visite** Photograph format patented by Disdéri in 1854. The appearance of these small portraits (approximately $10 \times 6$ cm; $3\frac{7}{8} \times 2\frac{3}{8}$ in.), glued on to cards the size of a visiting card, revolutionized the photographic industry. Between 1858 and 1870, the fashion for the *carte de visite* was at its height, although it continued to be used until the end of the 19th century.

**collodion process** Substance consisting of gun cotton dissolved in a mixture of alcohol and ether. Its use dates from 1848, when Frederick Scott Archer started perfecting the glass negative process, known as the wet collodion process (made public in 1851). Faster and more sensitive than the albumen on glass process, it remained, right up to the early 1870s, the photographic method most widely used. The delicate nature of the process led, from 1855 onwards, to the attempt to substitute it with the so-called dry collodion process. Although that process was much simpler to use, it proved to be much slower and did not meet with much success. Collodion on glass negatives stand out from subsequent negatives adopting silver bromo-iodide, because of the creamy-brown tone of the images and the greater thickness of the plates.

**cyanotype** Process using potassium ferricyanide, invented by the astronomer Sir John Herschel in 1842, producing images that were bluish in tone. A simple, inexpensive and resistant technique, it was used throughout the century, particularly in the reproduction of architectural drawings.

**daguerreotype** Photograph on metal, usually consisting of a copper plate covered with a fine layer of silver, giving it the appearance of a mirror.

Depending on the angle from which it is viewed, it can appear both negative or positive and is sometimes coloured using pigments. The daguerreotype is a unique image, ranging in format from roughly 7 × 5 cm ($\frac{1}{9}$th of a plate; $2\frac{3}{4} \times 2$ in.) to 16.5 × 21.5 cm (full plate; $6\frac{1}{2} \times 8\frac{1}{2}$ in.). For portraiture, the most popular plates were those measuring 8 × 7 cm (a sixth of a plate; $3\frac{1}{8} \times 2\frac{3}{4}$ in.), 10.5 × 8 cm (a quarter; $4\frac{1}{8} \times 3\frac{1}{8}$ in.) and, for groups, 16 × 12 cm (half plate; $6\frac{1}{4} \times 4\frac{3}{4}$ in.).

**direct processes** Refers to processes that provide unique images, without the use of any kind of matrix, such as a negative: ambrotype, ferrotype, daguerreotype, Bayard's direct positive process on paper, Fox Talbot's photogenic drawing.

**ferrotype** Used from the beginning of the 1850s, this process was similar to the ambrotype, but the glass plate was replaced by a plate of blackened iron. An extremely cheap and popular process, it was widely used right up to the 20th century by fairground photographers.

**gelatin dry plates** Process invented in the early 1870s by the Englishman Richard Leach Maddox and still used nowadays. Many improvements to the process were made during the 1870s and, by the beginning of the 1880s, it possessed the dual advantage of being extremely fast and simple to use, as the negatives could be prepared a long time in advance: superseding the collodion method, the dry plate negative became the principal player in the 'snapshot revolution'.

**photogenic drawing** Name given by Fox Talbot to the photographic process he invented between 1835 and 1838, allowing him to obtain unique, negative images, formed by the direct impression of an object placed on a sheet of sensitized paper and exposed to the light, and with the aid of a camera obscura. In 1835, he had the idea of obtaining, with the help of these 'photogenic drawings', images in which the values were reversed, 'negatives of negatives', or positive prints, an idea that he did not put into practice until 1851, with the invention of the calotype.

**photographer/photography** When the medium first made its appearance, the expression 'photographer' was often used for the apparatus, even the photographic image itself, and not its operator – known by the term 'photographist'. It was not until the second half of the 1850s that the present-day usage came into being. As for the expression 'photography', it was not until well into the 1850s that it assumed its generic meaning and was used principally to describe

all processes in which the image was formed by light. Up to the end of the decade, the terms 'daguerreotype' or 'heliography' continued to be used in the same sense, prior to assuming a limited meaning, the former referring to the process invented by Daguerre, the latter to the one to which Niépce had given his name.

**photomechanical (processes)** This expression, which was first adopted during the 1880s, is used to describe all the techniques in which the method of printing is mechanical. They flourished especially from the end of the 1850s and mainly included photogalvanography (Pretsch, 1854), photolithography (Poitevin, 1855), photoglyptic etching (Fox Talbot, 1858), photoglypt or woodburytype (Woodbury, 1864), collotype or albertype, heliotype, phototype (Albert, 1867), and finally, photogravure or heliogravure (Karel Klic, 1879) which was later adapted and improved.

**printing** The method of printing most widely practised during the early decades of photography was so-called contact printing: the negative was placed directly in contact with the paper, usually in a printing frame, and the image obtained, whether by being exposed to light (known as 'printing out') or through the use of a chemical substance (developer). The resulting prints were therefore the same size as the negative. The operation of enlarging the printed images was not adopted widely until much later, in the 1880s. Until then, the preferred method was to enlarge the negative directly and then to print the resulting images by the contact process.

**reversed (image)** In the 19th century, the term was used to refer to an image that was optically reversed (often in the early years of the daguerreotype), and to an image in which the values themselves were reversed, i.e. a 'negative'.

**stereoscopy** Photographic process that appeared at the beginning of the 1850s, allowing the reproduction of the illusion of relief: the image was taken using a device (the stereograph) conceived for taking two photographs of the same subject from slightly different angles, equal to the distance between the eyes. Developed and then stuck on to cardboard, the two photographs, measuring about 10 × 10 cm ($3\frac{7}{8} \times 3\frac{7}{8}$), were viewed with the aid of a binocular device, the stereoscope, which provided an impression of relief and depth. The vogue for stereoscopic photography lasted throughout the second half of the 19th century and it was practised right up to the interwar years of the 20th century.

# FURTHER READING

**General works**

Bernard, Bruce, *The Sunday Times Book of Photodiscovery*, 1980

Gernsheim, Helmut, and Alison Gernsheim, *The History of Photography: From the Camera Obscura to the Beginning of the Modern Era*, 1969

—, *The History of Photography Vol. 2: The Rise of Photography 1850–1880: The Age of Collodion*, 1988

Jeffrey, Ian, *Photography: A Concise History*, 1981

Lowry, Bates, and Isabel Barrett Lowry, *The Silver Canvas: Daguerreotype Masterpieces from the J. Paul Getty Museum*, 1998

Newhall, Beaumont, *The History of Photography from 1839 to the Present*, 1982

Rosenblum, Naomi *A World History of Photography*, 1997

**Chapter 1**

Arnold, H. J. P., *William Henry Fox Talbot*, 1977

Batchen, Gail, *Burning with Desire, The Conception of Photography*, 1999

Buckland, Gail, *Fox Talbot and the Invention of Photography*, 1980

*Photography: The First Eighty Years*, 1976

Schaaf, Larry J., *Out of the Shadows. Herschel, Talbot and the Invention of Photography*, 1992

**Chapter 2**

Borcoman, James, *Charles Nègre, 1820–1880*, 1976

Bretell, Richard, and R. Fluckinger, *Paper and Light: The Calotype in France and Great Britain 1839–1870*, 1984

Buerger, Janet E., *French Daguerreotypes*, 1989

Jammes, André, and Eugenia Parry Janis, *The Art of French Calotype*, 1983

**Chapter 3**

Gosling, Nigel, *Nadar*, 1976

MacCauley, A., *Industrial Madness. Commercial Photography in Paris 1848–1870*, 1995

Sobieszek, Robert, and Odette Appel, *The Spirit of Fact: The Daguerreotypes of Southworth and Hawes, 1843–1862*, 1976

**Chapter 4**

Gernsheim, Helmut, and Alison Gernsheim, *Roger Fenton, Photographer of the Crimean War: His Photographs and his Letters from the Crimea*, 1954

Naef, Weston J., and James N. Ward, *Era of Exploration: the Rise of Landscape Photography in the American West, 1860–1885*, 1975

Newhall, Beaumont, and Nancy Newhall, *T. H. O'Sullivan, Photographer*, 1966

Sandweiss, Martha A. (ed.), with essays by Alan Trachtenberg, *Photography in Nineteenth-Century America*, 1991

**Chapter 5**

Bartram, Michael, *The Pre-Raphaelite Camera. Aspects of Victorian Photography*, 1985

Ford, Colin, and Roy Strong, *The Hill Adamson Collection: An Early Victorian Album*, 1974

Ovenden, Graham, *A Victorian Album: Julia Margaret Cameron and her Circle*, 1975

Scharf, Aaron, *Art and Photography*, 1974

**Chapter 6**

Earle, Edward W. (ed), *Points of View: The Stereograph in America: A Cultural History*, 1979

Hamber, Anthony J., *A Higher Branch of the Art. Photographing the Fine Arts in England, 1839–1880*, 1995

# LIST OF ILLUSTRATIONS

The following abbreviations have been used:
*a* above; *b* below; *c* centre; *l* left; *r* right;
BN Bibliothèque nationale de France, Paris;
MO Musée d'Orsay, Paris; SFP Société française de Photographie, Paris.

### COVER

**Front** Nadar, *The Mime Artist Deburau as Pierrot Photographer*, 1854–5. Salted paper print. MO
**Spine** Lewis Carroll, *Portrait of Marion Terry*, 13 July 1865. Collodion glass negative. MO

**Back** Eadweard Muybridge, *Gallop* (detail), 1878–9. Albumen print. The J. Paul Getty Museum, Los Angeles

### OPENING

*1* Lewis Carroll, *Portrait of Marion Terry*, 13 July 1865. Collodion glass. MO
*2* John B. Greene, *The Colossus of Thebes*, 1854. Salted paper print. MO
*2–3* John B. Greene, *The Colossus of Thebes* (detail), 1854 . Paper negative. MO

# INDEX

# ACKNOWLEDGMENTS

The author would like to thank Henri Loyrette, Fabrice Golec, Patrice Schmidt, Alexis Brandt, Frédérique Kartouby. The publishers would like to thank Marc Pagneux, Bodo von Dewitz, Agfa Foto-Historama and Dr Leslie Gordon, The Robinson Library, University of Newcastle upon Tyne.

## PHOTO CREDITS

Agfa Photo-Historama, Ludwig Museum, Cologne 21, 50. The American Geographical Society Collection, University of Wisconsin–Milwaukee Library 75. Archives de Paris, Patrick Léger 70. The Art Institute of Chicago 76–7. Atelier de photographie du Centre historique des Archives nationales, Paris 23. Bayerische Staatsbibliothek, Munich 88. Bibliothèque des Arts décoratifs, Fonds Le Secq, Paris 46. Bibliothèque nationale de France, Paris 25a, 25c, 35, 38b, 51, 58, 59b, 61, 63l, 63r, 78, 82, 84a, 89, 94a, 94b, 101, 103, 112a, 119a, 120, 131, 135, 145. The Bridgeman Art Library, Paris 13. Corbis-Sygma, Paris 52, 125a, 125b. Ecole nationale supérieure des Beaux-Arts, Paris 81b. The Fox Talbot Museum, Lacock 19a, 112–113. Fratelli-Alinari archives, Florence 126. George Eastman House, Rochester 31. The J. Paul Getty Museum, Los Angeles back cover, 86–7, 93, 100–101. Gilman Paper Company Collection, New York 44, 79. Harry Ransom Humanities Research Center, The University of Texas, Austin 17, 105. Hochschule der Künste, Hochschulbibliothek/Markus Hilbich, Berlin 48l. Hulton Deutsch Collection/Corbis, Paris 107. Keystone-L'Illustration, Paris 14a. Kröne-Sammlung, Institut für Angewandte Photophysik, Technische Universität, Dresden 62. The Metropolitan Museum of Art, © 1998, New York 97. Münchner Stadtmuseum, Fotomuseum, Munich 24. Musée des Arts et Métiers/CNAM, Paris 25b. Musée des Arts et Métiers/CNAM, Paris/Pascal Faligot-Seventh Square 22a. Musée français de la Photographie, Bièvres 34–5. Musée d'Orsay, Paris/Documentation 14b, 16, 27, 32a, 32b, 48r, 55a, 60b, 66a, 84b, 119b, 137, 139, 140. Museum of Fine Arts, Boston 37. Muséum national d'Histoire naturelle, Paris/Patrick Lafaite 114. National Galleries of Scotland, Edinburgh 41, 117b. National Museum of American History, Smithsonian Institution, Washington, D. C. 29, 33a. National Portrait Gallery, London 98. NMPFT/Science & Society Picture Library, London 19c, 42–3. Photothèque des Musées de la Ville de Paris 15. Photothèque des Musées de la Ville de Paris/Briant 90. Photothèque des Musées de la Ville de Paris/Ladet 66b. Préfecture de Police. All rights reserved, Paris 74, 127. The Robinson Library, University of Newcastle upon Tyne 112b. RMN, Paris 9, 108, 117a. RMN/Michèle Bellot 57. RMN/J.-G. Berizzi 34, 91. RMN/Alexis Brandt spine, 1, 2, 2–3, 4–5, 6–7, 8–9. RMN/Béatrice Hatala 11, 77, 116. RMN/C. Jean 49, 73, 109. RMN/Hervé Lewandowski front cover, 38a, 64, 65, 68r, 69, 81a, 96, 100, 110, 121, 122, 128. RMN/Franck Raux 7. RMN/Patrice Schmidt 4, 33b, 39, 45l, 47a, 53, 54, 55b, 56a, 56b, 68l, 72, 111, 115, 124. Roumagnac Photographe, Montauban 95. Royal Astronomical Society, London 82–3. The Royal Photographic Society, Bath 18, 86, 104, 106–107, 123. Science and Society Picture Library, London 19b. Société française de Photographie, Paris 22b, 26, 45r. Studio Basset, Villeurbanne 59a. Victoria and Albert Picture Library, London 30, 71, 92, 99. Ville de Chalon-sur-Saône, Musée Nicéphore-Niépce 12, 85. Yale Collection of Western Americana, The Beinecke Rare Book and Manuscript Library, Yale University, New Haven 80.

## TEXT CREDITS

Grateful acknowledgment is made for use of material from the following work:
(pp. 148–9) Reproduced from *Art in Paris 1845–1862* by Charles Baudelaire, edited and translated by Jonathan Mayne © 1965 Phaidon Press Ltd.

Quentin Bajac
has worked as a curator
at the Musée d'Orsay since 1995.
He has been responsible for several
exhibitions on 19th-century photography,
including 'En collaboration avec le Soleil,
Victor Hugo, photographies de l'exil'
(1998), 'Tableaux vivants, Fantaisies
photographiques victoriennes' (1999),
'La Commune photographiée' (2000) and
'Dans le champ des étoiles: les photographes
et le ciel, 1850–2000' (2000).
He is currently preparing an exhibition
on French daguerreotypes.

CRAVEN COLLEGE

Translated from the French by Ruth Taylor

First published in the United Kingdom in 2002 by
Thames & Hudson Ltd, 181A High Holborn,
London WC1V 7QX

www.thamesandhudson.com

English translation © 2002 Thames & Hudson Ltd,
London, and Harry N. Abrams, Inc., New York

© 2001 Gallimard/Réunion des musées nationaux

All Rights Reserved. No part of this publication may
be reproduced without prior permission in writing
from the publisher

British Library Cataloguing-in-Publication Data

A catalogue record for this book is available
from the British Library

ISBN 0–500–30111–5

Printed and bound in Italy
by Editoriale Lloyd, Trieste